Van Gogh

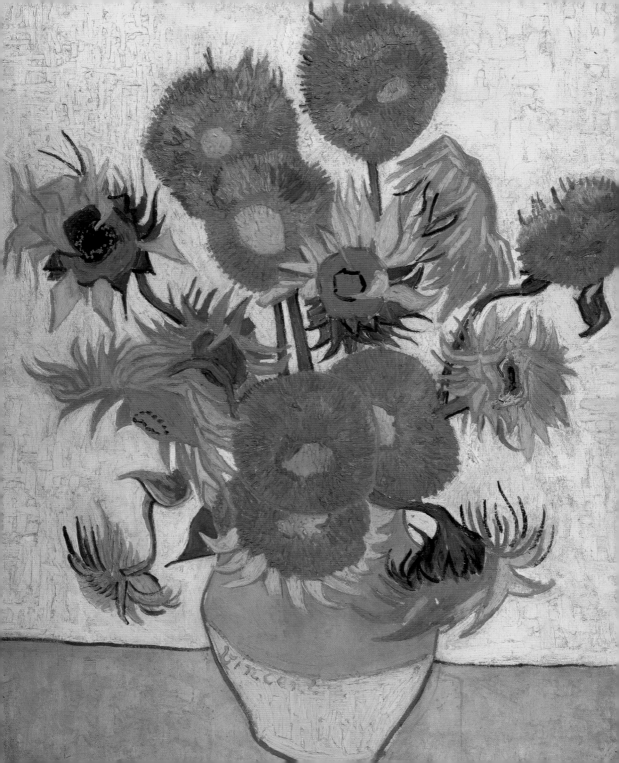

Masters of Art

Van Gogh

Paola Rapelli and Alfredo Pallavisini

PRESTEL
Munich · London · New York

Front cover: *Café Terrace at Night*, 1888, Kröller-Müller Museum, Otterlo (detail),
see page 100
Frontispiece: *Sunflowers*, 1889, Van Gogh Museum, Amsterdam (detail)
Back cover: *Self-Portrait as an Artist*, 1888, Van Gogh Museum, Amsterdam (detail),
see page 72

© Prestel Verlag, Munich · London · New York, 2012. Reprint 2014
© Mondadori Electa SpA, 2007 (Italian edition)

British Library Cataloguing-in Publication Data: a catalogue record for this book is available from
the British Library; Deutsche Nationalbibliothek holds a record of this publication in the Deutsche
Nationalbibliografie; detailed bibliographical data can be found under: http://dnb.d-nb.de

Library of Congress Number 2011942809

Prestel Verlag, Munich
A member of Verlagsgruppe Random House GmbH

Prestel Verlag
Neumarkter Strasse 28
81673 Munich
Tel. +49(0)89 4136 0
Fax +49(0)89 4136 2335

www.prestel.de

Prestel Publishing Ltd.
14–17 Wells Street
London W1T 3PD
Tel. +44 (0) 20 7323-5004
Fax +44 (0) 20 7323-0271

Prestel Publishing
900 Broadway, Suite 603
New York, NY 10003
Tel. +1 (212) 995-2720
Fax +1 (212) 995-2733

www.prestel.com

Prestel books are available worldwide. Please contact your nearest bookseller or
one of the above addresses for information concerning your nearest distributor.

Editorial direction: Claudia Stäuble, assisted by Franziska Stegmann
Translation from German: Jane Michael
Copyediting: Chris Murray
Production: Astrid Wedemeyer
Typesetting: Stephan Riedlberger, Munich
Cover: Sofarobotnik, Augsburg & Munich
Printing and binding: Elcograf, Verona, Italy

FSC
www.fsc.org
MIX
Paper from
responsible sources
FSC® C115118

ISBN 978-3-7913-4659-5

Contents

Introduction

Van Gogh was not particularly good at painting. He knew that, and he suffered because of it. He admired those artists who were able to paint subtle details, the brilliance and the elegance of academic paintings. Compared with such works, his paintings always looked dirty, cobbled together, coarse, covered with grease or dust. He practiced drawing by copying Eugène Delacroix and Jean-François Millet but he would also have liked to achieve the magnificent and spectacular effects of the painters who were fashionable at the time and who were greeted with applause from the public in the yearly Salon exhibitions in Paris. Plagued by confused ambitions that were repeatedly disappointed, Van Gogh's early years were unhappy and lacking in purpose. He frequently changed his place of residence and his job, vacillating between unsuccessful religious ambitions and work as a warehouse laborer, between life among the miners in the Borinage district in Belgium and the warehouses of London. His promising baptismal name, Vincent, the "victorious one," must have sounded like a mockery to him, for he felt himself to be a born loser. And then, one day, he encountered the works of Rembrandt. Van Gogh, whose calling it would be to change the course of art, who was in a position to drive painting beyond the complacency of Impressionism, and who was destined to become one of the greatest revolutionaries of art history—this young man suddenly discovered himself as he stood, deeply impressed, in front of the engravings and paintings of the Dutch master. In his letters Van Gogh immediately adopts an awed tone when he tells of his visits to the Rijksmuseum in Amsterdam. Perhaps no one has ever looked at these pictures with such passion and sympathy: standing in front of *The Jewish Bride* or *The Anatomy Lesson of Dr. Deyman* he forgot everything around him; he wanted only to stay, never to leave, to live on bread and water—and Rembrandt. At the beginning he experienced a vague feeling of ecstasy; then a delightful shudder ran through him, and then, with increasing clarity, a feeling of purpose overcame him which he could not escape. Van Gogh identified closely with Rembrandt, finally concluding: "You have to die more than once to be able to paint like this." He adopted in his own works the same vigorous application of paint, somber but yet absolutely true—hands and feet of flesh and blood, caked with grime or soil and worn with endless work would never entirely disappear from his paintings. Even under the sun of Provence, under the bright skies of the south, which are intensely blue during the day and spangled with stars at

night, far away from the misty canals of Amsterdam, Van Gogh still practiced copying Rembrandt's engravings and attempted to re-interpret their chiaroscuro in yellow and red, to imbue his works with the merciless power of his colors. Throughout his life Van Gogh found it impossible to sell his paintings, and like his great Dutch artist forebear he found himself facing the darkest sides of human failure. But Rembrandt had a family to support him and was able to fight back, to survive despite tragedy and hardships; Van Gogh was alone and his struggles destroyed him. Like a shipwrecked man he listed the few things that he had left after the tempests of his life: a pair of worn-out shoes; a chair whose straw seat was broken; a well-used pipe; the memory of a blossoming branch of a peach tree. The lights of the city of Paris were extinguished; the banality of the daily routine paled—but Van Gogh now saw how the stars moved across the sky; how the gnarled branches of the olive tree stretched out in all directions; how the ripe cornfields glowed intensely yellow under dark skies; how the blossoms, even in the courtyard of the mental hospital, unfailingly unfolded their magnificence; and how butterflies landed on poppies. Van Gogh's path was a stony one: he was burned out after only a few years, tortured by demons of loneliness, of not being understood, exhausted by an indissoluble inner dissatisfaction. The breathless course of his short life allows us to forget all too easily the painful intensity to which Van Gogh exposed himself, notably in subjecting his own face and emotions to intense scrutiny in his painting, as Rembrandt had two and a half centuries before. In this sense alone, through the unconditional seriousness and commitment of a difficult character, through his eyes filled with light and his continuing mental anguish, Van Gogh stands head and shoulders above his contemporaries. True, he did paint badly, in terms of the standards of the Academy—but he painted the truth. Every gesture, every brushstroke, every trace he left behind on the canvas has become holy, perhaps a final act: we can count, piece by piece, the colored strokes and the thick clumps of paint. At a time when a refined and even effete Symbolism was being discussed by artists and intellectuals settled in the velvet armchairs of the Salon exhibitions, Van Gogh created a legacy based on an intense and ultimately tragic commitment to his art. His impact on the development of modern art was immense.

Stefano Zuffi

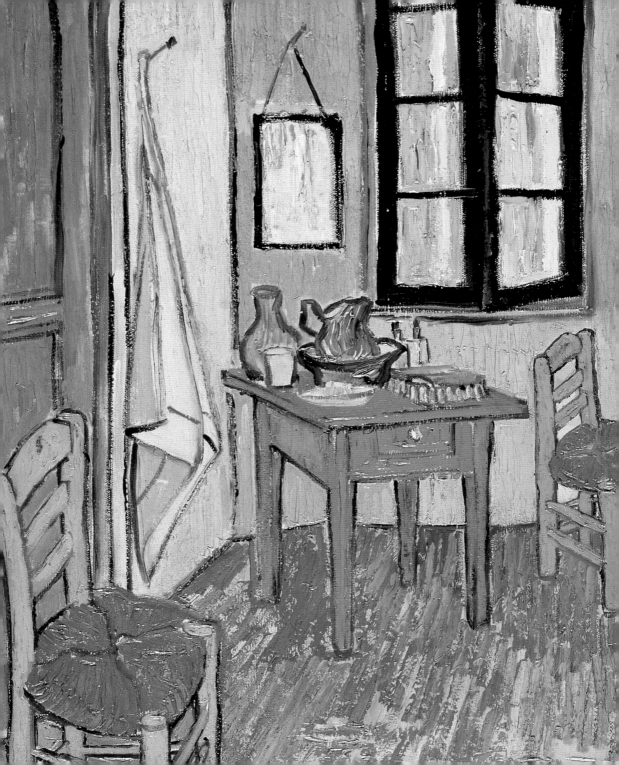

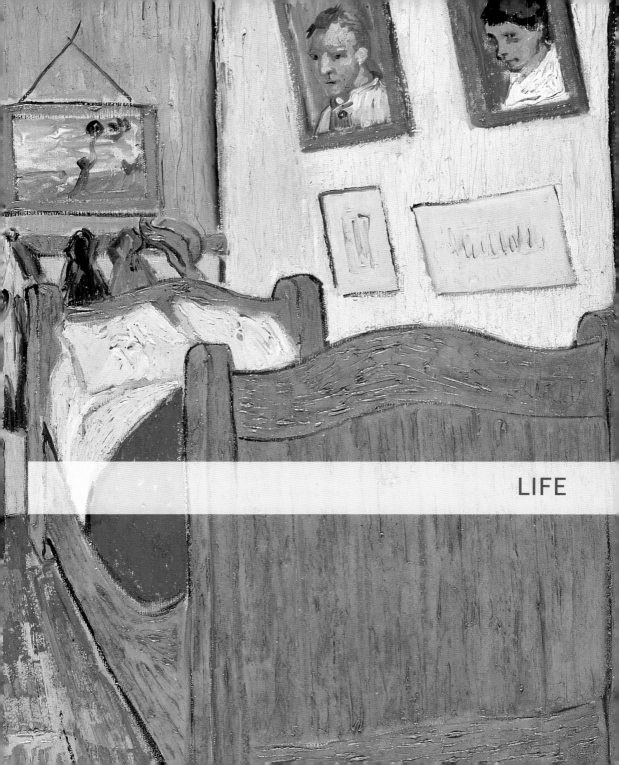

LIFE

Drama and Passion in a Cornfield

In April 1849 Vincent van Gogh's father, Theodorus Van Gogh, was appointed Calvinist pastor of Groot Zundert, a remote little town in the Netherlands province of Brabant. He was twenty-seven years old and it was his first parish. As careers go it was a modest start: of the 6,000-odd inhabitants of Groot Zundert, scarcely one hundred were members of the Calvinist congregation; but young Theodorus could cope with that. Indeed, he would later pursue quite a successful career.

He was not a brilliant personality; though he had completed a theology course at the University of Utrecht, he was not intellectually gifted, and he was a mediocre preacher. But he was lovable and generous, very warm-hearted and blessed with very good looks (the people in the village even called him the "handsome pastor").

His limited abilities did not bother him; he observed that a good priest proved himself with his heart and through living an exemplary life rather than through preaching fine sermons. Everyday life would prove him right, and after a short time he had won the respect and affection not only of the faithful in his congregation, but also of their Catholic fellow-citizens.

The wife whom Theodorus Van Gogh took with him to Groot Zundert was Anna Cornelia Carbentus. She came from a respected family in The Hague that could count a bishop among its ancestors. Her father, Willem Carbentus, was a well-known and prosperous bookbinder who had had the honor of binding the constitution of the Netherlands and who was therefore entitled to use the title "Book Binder by Royal Appointment." A younger sister married (another) Vincent van Gogh—one of Theodorus' brothers, and generally known as Uncle Cent—who later achieved a degree of prosperity as an art dealer.

Aged thirty-two when they married, Anna Cornelia was a gentle and tender young woman. She was hard working and active, sometimes a bit stubborn, but with her optimism, which not even the somewhat monotonous life in Groot Zundert could dampen, she was a valuable support in her husband's pastoral work. This mental robustness, together with Theodorus' firm faith, helped the couple to come to terms with the loss of their first-born child, who was stillborn on 30 March 1852. Exactly a year later, on 30 March 1853, Anna gave birth to another child, this time a strong, healthy son, whom they named Vincent Willem after their first child and the two grandfathers. He was followed in rapid succession by further children: Anna, Theodorus, known as Theo, Elisabeth, Wilhelmina, and Cornelius.

Van Gogh's childhood

Vincent enjoyed a bright, carefree childhood in the cornfields and pine forests of Groot Zundert. There was no hint that something

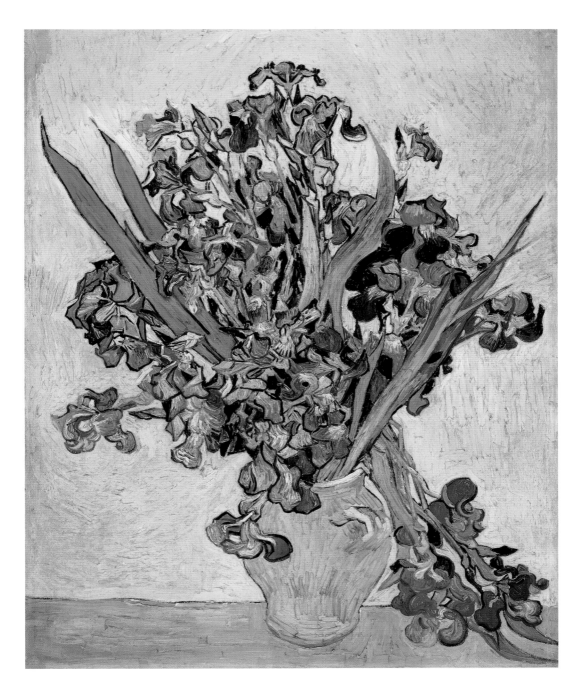

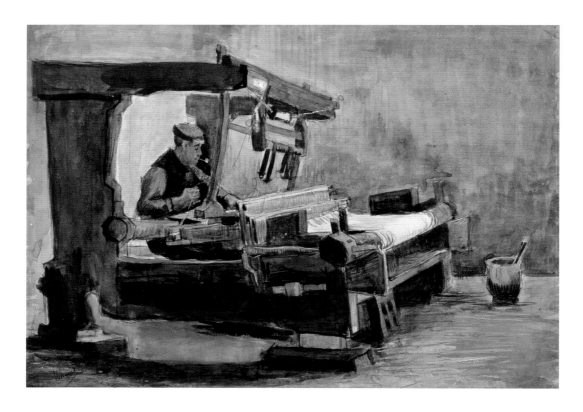

The Weavers, 1884,
Van Gogh Museum,
Amsterdam

might come along to disturb the well-ordered existence in this heathland landscape, where life sometimes seemed to stand still for a moment, as if things there took place beyond the confines of space and time. These years engraved themselves indelibly on Van Gogh's soul, and he would later look back longingly at the little cottage in Groot Zundert: "During my illness," he would write in January 1889, "I could see before me every room in the house in Zundert, every path, every plant in the garden, the surroundings, the fields, the neighbors, the cemetery, the church with our vegetable garden behind it—even the magpie's nest in the tall acacia tree in the cemetery."

Having previously attended the village school, in 1864, at the age of eleven, Van Gogh transferred to Jean Provily's boarding school in Zevenbergen, a small town some 25 kilometers north of Groot Zundert. He remained there until September 1866 and then attended the middle school in Tilburg for one and a half years.

In March 1868 he suddenly left school and returned to Groot Zundert. We know little about Vincent's schooling during these four years. He seems not to have been a very good pupil. He read all sorts of books, but not those which his teachers gave him. We also do not know why his schooling was interrupted; some authors surmise that it was because of financial difficulties in the family, while others ascribe it to his rather poor performance.

Van Gogh in The Hague: an exemplary employee

Van Gogh did not show any particular inclinations regarding a career and found it hard to feel enthusiasm for anything specific. Furthermore, his character was rather unsteady and his moods frequently changeable, sometimes making him unbearable. In Zevenbergen he had practiced academic drawing from a live model with a degree of success, but that was not sufficient for the fifteen-year-old to feel that he was predestined for an artistic career. So eventually his parents asked his Uncle Cent, who ran a successful art gallery, to help. A short while previously Uncle Cent had retired from business life for health reasons and had ceded his successful gallery on De Plaats (the main square) in The Hague to the Paris-based firm of Goupil. If his nephew was in agreement, he wrote back, his uncle would speak to Goupil about giving him a job. Vincent eventually agreed, and on 30 July 1869 the future artist moved to The Hague and took up lodgings in the house of the Roos family on the Beestenmarkt. The next day he presented himself to Hermanus Tersteeg, the director of the Goupil branch office, and so started his training under his direction. From the reports Tersteeg sent at regular intervals to the Pastor in Groot Zundert regarding the progress of his son, we gain a picture of an exemplary employee: he was responsible, hard-working, punctual, "eager and ambitious," serious but "with a friendly manner towards everyone"— in short, Tersteeg assured him, Vincent had excellent prospects.

In the meantime, his father Theodorus was appointed in January 1871 to the parish of Helvoirt in another small town in Brabant some 50 kilometers from Groot Zundert, and the family moved house a few weeks later. It was here, in the vicarage of Helvoirt, that Van Gogh spent his summer holidays in 1872 with his family, whom he had not seen for almost three years. For a few weeks the Van Gogh family was reunited as in the good old days in Groot Zundert. Van Gogh's favorite brother, fifteen-year-old Theo, who went to school in Oisterwijk, a town near Helvoirt, was also there. Vincent had much to report from The Hague, about his friends, his work, and his plans for the future. Theo in particular—a boy who already seemed much older than his years—listened attentively to what his elder brother said. Then, in August, Theo spent a few days in The Hague as Vincent's guest, since the latter had returned to work for Goupil. We do not know what the two brothers talked about at this stage; presumably Vincent's work in the art gallery, and so about art, about the family's financial problems and what could be done about them, and about their futures. It was during his short visit to The Hague that Theo's decision to leave school and find a job probably took shape. In any case, he left school at the end of 1872 and took up the post of assistant in the Belgian branch office of Goupil, once again thanks to the intervention of Uncle Cent. Towards the end of the month the regular correspondence between Vincent and Theo began and would continue until the artist's death, a dialogue about the experiences of both men, about art and life. It is above all one of the most intimate personal testimonials ever written by an artist.

Van Gogh in London: an "eccentric" employee

The owners of Goupil proposed that Van Gogh should move to the—highly popular—London branch, a well-earned reward for four years of valuable assistance and exemplary behavior. Although the future artist was saddened to leave the Netherlands, he nonetheless traveled to England in June 1873. He enjoyed his new situation: the work was less

demanding than in The Hague, and he also earned well, so that despite his high living expenses he could even manage to send his parents some money. During this time Van Gogh was cheerful and carefree; he joked about the eccentricities of the Londoners and wrote to his brother that he had bought himself a top hat ("In London you just can't manage without a top hat"). He went for long walks along the banks of the Thames, sometimes stopping to record the landscape in quickly executed sketches.

Then he fell unhappily in love shortly before the summer holidays in July 1874, was rejected and returned to his parents deeply depressed and inconsolable. At the end of July Van Gogh returned to London accompanied by his eldest sister, Anna, who hoped to find a job as a housekeeper; her company was also supposed to cheer him up. The brother and sister lived in Ivy Cottage at 395 Kensington New Road. Despite all the concern, however, Van Gogh's spirits did not improve; his mental state became worse, in fact. He was morose, irritable and lethargic; he wrote less frequently to Theo and his parents and the letters he did write became gloomier and more confused. Even at work he was no longer his old self: the formerly exemplary employee had become a listless, penniless young man whose heart was not in his work. His parents were alarmed and contacted long-suffering Uncle Cent once more. The latter achieved a temporary transfer to the Paris branch of Goupil. The family thought that a brief change of environment would improve Vincent's spirits. In fact Van Gogh was irritated by this move, which he had not requested, but in October 1874 he traveled to Paris—interrupting his correspondence with his parents for several weeks by way of protest. At the end of the year he returned to London. Theo's wife Johanna Bonger, who would later write a biography of the artist's life, reported that Vincent continued

his "lonely, retiring life" and commented: "For the first time he was described as 'eccentric'."

In Paris: the first signs of a religious crisis

In May 1875 the young Van Gogh was transferred permanently to the headquarters of Goupil in Paris. He brought with him from England an insatiable religious longing. Even before his departure he described his mental state very clearly in a letter to his brother Theo, in which he stated, amongst other things: "Man is not here on earth only to be happy. He is not even here simply to be decent. He is here to carry out great things." And, adapting a quotation from the Gospels: "To act on the world one must die to oneself. The people that makes itself the missionary of a religious thought has no other country henceforth than that thought."

In Paris Van Gogh's religious enthusiasm acquired fanatical characteristics. His letters to his parents and to Theo were interspersed with biblical quotations. In his room in Montmartre ("the hut," as he called his accommodation) he spent hours reading and commenting on the Bible together with Harry Gladwell, a colleague who was also interested in religious and mystical questions. However, he tackled the subject with such grim determination that his British friend soon found him disturbing.

Van Gogh found his work increasingly difficult to complete and his behavior acquired certain absurd qualities—such as advising customers not to buy certain paintings he did not like. However, he continued to show great interest in painting and visited exhibitions and museums in Paris regularly, especially the Louvre.

Just before Christmas 1875 he left his job unannounced and traveled to his parents' house in Etten, a village near Breda, where his father had been working since October of

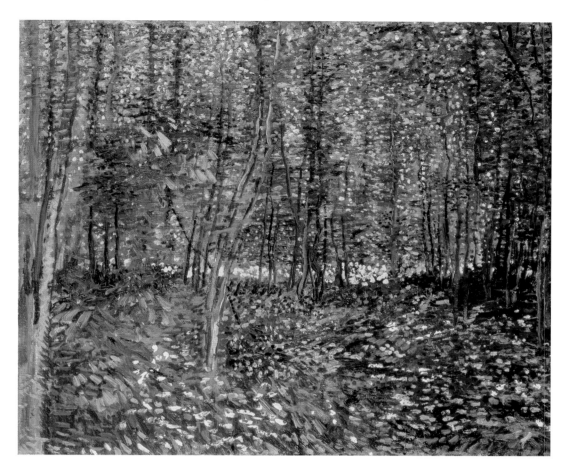

Wood and Undergrowth,
Summer 1887,
Van Gogh Museum,
Amsterdam

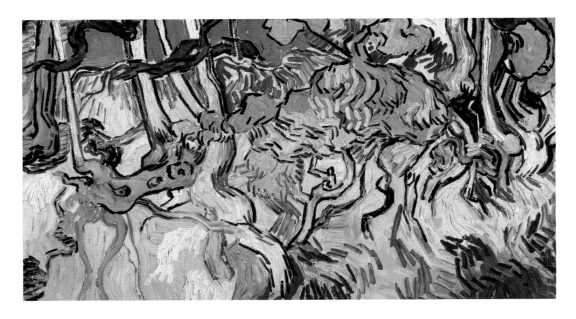

that year. His employers at the gallery were annoyed, and when the young Van Gogh returned to Paris in early January 1876 they persuaded him to hand in his notice. However, this notice was effective from 1 April, presumably as a concession to his Uncle Cent. After spending a fortnight with his parents in Etten, Van Gogh traveled back to England on 16 April. Through a newspaper advertisement he had found a job as assistant teacher in the school run by a William Stokes in Ramsgate in Kent; his salary, however, consisted merely of free board and lodging. In July he followed Stokes and his school to Isleworth, a working-class suburb of London. Shortly after that he accepted an offer to work as a teacher and assistant preacher for the Reverend Thomas Slade-Jones, a Methodist minister.

His mission: the care of souls

In December Van Gogh returned to Etten to spend the Christmas holiday there. He seemed upset and he was in poor physical condition, and his parents were seriously worried about him. Once again reliable Uncle Cent stepped in and arranged a job for him in the bookshop of Blussé and Van Braam in Dordrecht.

Van Gogh took up his new post in January 1877. However, he buried himself more and more in the study of religious writings; he read and translated the Bible from Dutch into French, German, and English and he took part in religious services—including those of other confessions—every day. He repeatedly stated that he wanted to "care for people's souls" like his father; he had become obsessed by the desire to "proclaim the Gospel."

By contrast, he took little pleasure in his work. To compensate he began to draw with great enthusiasm, and soon, despite the protests of his landlords, Mr and Mrs Rijken, drawings covered the walls of his room.

His interlude in Dordrecht came to an ignominious end after four months, and by the end of April Van Gogh was back in Etten. He

was now more determined than ever to devote himself to pastoral care. His father still supported his intention and in May agreed that his son could go to Amsterdam to prepare for the entrance examination to study theology at Amsterdam University.

With the exception of his Uncle Cent, who was openly against the plan, the entire family endeavored to support Van Gogh in his efforts: he lived with his Uncle Jan (Johannes Van Gogh), who was responsible for the wharves in the city; Pastor Stricker, a maternal uncle, introduced him to his nephew Dr. Mendes da Costa, one of the best teachers of Greek and Latin in the city, and later personally taught him mathematics.

Van Gogh threw himself with energy and determination into his studies, but the results were disastrous. In July 1878 he gave up, left Amsterdam and returned to his parents' home.

"Give everything to the poor"

However, he did not give up his original plan for a ministry. In August he began a three-month course at a seminary for lay preachers in Brussels. Completing the course would have permitted him to give religious instruction to the poor and to undertake charitable work. Vincent's parents watched this latest attempt on the part of their son to find a place in society with growing concern. Although at the end he was the best-prepared candidate from the course, the leaders denied him the title of lay preacher because he "lacked the capacity to accept a subordinate position."

He was hurt, but—as so often—he refused to show it. In December 1878 he traveled at his own expense to the mining region of Borinage on the Belgian/French border. There he rented a place in Pâturages, a village near Mons, for 30 francs a month, and began missionary work on his own account.

It may have been at the insistence of Pastor Van Gogh that the college of lay preachers in Brussels gave him a temporary post as a lay preacher in Wasmes, which lay near Pâturages, for a period of six months. For 50 francs a month he was to give Bible instruction and help the sick. He devoted himself totally to his task, was satisfied and even quite happy for once. But the enthusiasm with which he aimed to help his neighbors soon seemed fanatical. He gave the poor everything he owned: money, clothes, even his bed. Finally, he even gave up his modest accommodation in the house of the baker Jan Denis and moved into a shack, where he slept on straw. The director of the college for lay preachers in Brussels found this piety exaggerated and decided not to extend his contract at the end of the six months.

In his despair, Van Gogh went on foot to Brussels and asked Pastor Pietersen, a member of the committee of lay preachers and an amateur painter, for advice. At Pietersen's suggestion he remained in the Borinage region at his own expense. He moved to Cuesmes, where he continued his pastoral ministry as a private citizen, working himself to the point of complete exhaustion. He lived in the most abject poverty: though his brother Theo and his parents repeatedly sent him money, he spent many days hungry and totally without funds. Feeling lonely and abandoned, he began to doubt his faith. Maybe he felt he was accursed, abandoned by God, who until then had been his only hope. It was a realization that would change his life.

In October, he was visited by Theo, who strongly disagreed with his brother's decision to remain in the Borinage region. Theo attempted in vain to persuade Vincent that he should make plans for his future. Vincent was angered by his brother's interference, and in a fit of pique he stopped writing to his family, including Theo.

First steps in art

The winter of 1879–1880 was the saddest, most despairing, most terrible period of Van Gogh's life. In July 1880, after nine months of silence, he wrote to Theo again, who had been transferred to the Paris office of Goupil. It was a long letter, a moving, clear-sighted and frank account of his mental state after the dreadful winter in Cuesmes in which he announced his final, irrevocable decision regarding his future: he was going to devote himself entirely to painting. The relevant section of the letter is disarmingly honest and free of false modesty: "It's true that sometimes I've earned my crust of bread, sometimes some friend has given me it as a favor; I've lived as best I could, better or worse, as things went; it's true that I've lost the trust of several people, it's true that my financial affairs are in a sorry state, it's true that the future's not a little dark, it's true that I could have done better, it's true that just in terms of earning my living I've lost time, it's true that my studies themselves are in a rather sorry and disheartening state, and that I lack more, infinitely more than I have. But is that called going downhill, and is that called doing nothing? … if I do nothing, if I don't study, if I don't keep on trying, then I'm lost."

So what should he do? "I said to myself: whatever the position, I shall get back on my feet again; I shall take up my pencil … and I shall go back to drawing; and since then it seems to me as if everything has changed, and I am on the right path."

With the same stubborn energy with which he had pursued his preaching in the remote villages of Borinage, he now completed one drawing after another in rapid succession, fascinated in particular by the farm workers on their way to work and also by the works by Jules Breton and Jean-François Millet, of which he made copies.

Cuesmes became too small for him, and so in October 1880 he moved to Brussels. There he enrolled at the Academy of Art, because he realized that he was lacking knowledge of anatomy and perspective. Above all, however, he wanted to find a "real artist" so that he could continue his studies "in a real studio."

In November, with Theo's help, he established contact with a well-to-do young painter called Anthon Ritter van Rappard, a fellow Dutchman who was somewhat younger than Van Gogh. The two established a deep-seated friendship that lasted no less than five years— a record for the notoriously difficult Van Gogh. He continued to draw and made considerable progress, as he wrote himself, although he was really his own most rigorous critic.

On 12 April 1881 he traveled to Etten, because life in Brussels had become too expensive for him, and because he would be able to see Theo there. Thus he was able to discuss his plans and his art with someone close to him. No one would be better able to assess the artistic value of his drawings, make suggestions, and give him useful tips than his brother, who now held a prestigious position at Goupil. While in Etten, where Anthon van Rappard visited him, he drew landscapes and figure studies from nature.

Starting to paint

During the summer of 1881 his cousin Kate Vos-Stricker (Kee) was visiting the vicarage in Etten. The daughter of Pastor Stricker and the mother of a four-year-old child, she had recently been widowed. Van Gogh fell hopelessly in love with the young woman, but she wanted to have nothing to do with him. In order to escape the increasingly importunate "siege" by her suitor she left Etten and returned to her parents in Amsterdam. But Van Gogh refused to give up. In the fall he went to Amsterdam, where he tried in vain to see Kee again. Finally, and deeply disappointed, he gave up and reluctantly returned to Etten.

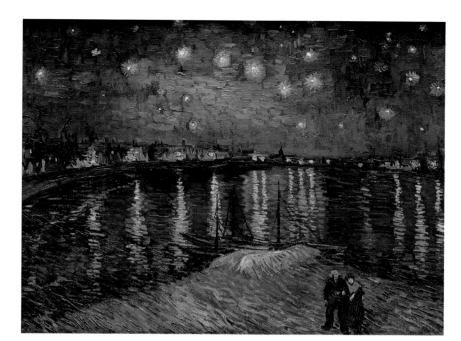

There he continued to draw, sketching everything he saw. He made remarkable progress, as even Anton Mauve confirmed, one of the outstanding representatives of The Hague School of painting. Van Gogh visited him frequently and in November/December 1881 stayed with him for a month.

Now, after Mauve had instructed him in the technique, Van Gogh attempted oil painting for the first time. He painted five pictures as well as figurative watercolors after models. After his return to Etten his mental state deteriorated and he became more agitated by the day. The excessive amount of work he demanded of himself made him unbearable, and he lost his temper over the slightest thing; in particular, he frequently quarreled with his father, who had not forgiven him for the episode with Kee. After a heated exchange on Christmas Day, Van Gogh finally left and sought a place to live in The Hague. There he

lived near Mauve, who was able to follow his development as a painter. He gave him advice and lent him money until the promised monthly payments from Theo arrived.

At the end of January Van Gogh met Clasina Maria Hoornik, known as Sien. The thirty-year-old prostitute had a son and was pregnant again. She drank, smoked cigars incessantly, and her face was disfigured with pock marks. Van Gogh took her into his home and looked after her. She became his model and—to the horror of his family and friends—his mistress. Van Gogh's artist colleagues distanced themselves from him, and even Mauve broke off contact with Van Gogh, who refused to abandon his chosen path; he was growing used to loneliness.

In search of solace, he drew studies from nature. He found his models in the working-class districts of The Hague, where he incessantly walked the streets in search of subjects.

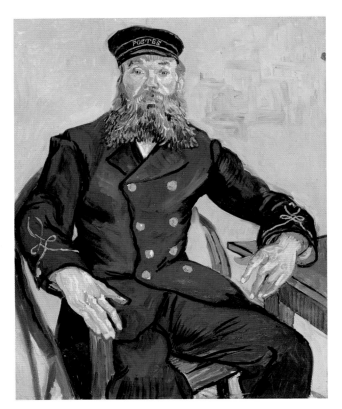

Portrait of Joseph Roulin, Seated, July/August 1888, Museum of Fine Arts, Boston

The peasants of Nuenen: echoes of Millet

The relationship with his family settled down and they reached a silent agreement as to how live together. "A great deal of affection and patience was necessary on both sides," wrote his sister-in-law Johanna, Theo's wife, but the efforts were clearly successful, for Van Gogh was to stay in Nuenen for two years. This was one of his most creative periods, during which he produced some 200 paintings and countless watercolors and drawings. He set up a studio in one of the vicarage outhouses that until then had been used as the laundry. In May 1884 he moved into the house of Schafrath, the Catholic verger, where he had two rooms at his disposal. He worked with wild determination, producing landscapes, still lifes, and portraits of the peasants of Nuenen: "weavers and looms, spinners and peasants planting potatoes."

Van Gogh unreservedly admired Jean-François Millet, the painter of the *Angelus* (1859), a work that became widely popular as a print. He was fascinated by Millet's works and his attitude to his subjects: "I see the first rays of dawn, but I also see the steam of the horses working on the plain, and then, somewhat to one side, a man bent double ... who attempts to stretch for a moment in order to be able to breathe." In his works the French artist expressed the almost mystical concepts of the writer Jules Michelet: "The peasants are not only the biggest but also the strongest and healthiest and—if we carefully consider all physical and moral factors—also, in general, the best part of the people."

During this time the relationship between Vincent van Gogh and his parents remained in a precarious balance. Their motto was "live and let live," but his father suffered when he saw how his son seemed to withdraw farther and farther from family life, as he complained

Apparently, only Theo was able to do anything: he finally succeeded in getting Vincent to leave Sien in the summer of 1883. He made him realize that she would return to her accustomed occupation again after the birth of her second child, and that he would not be able to "save her" as he had hoped. But for Van Gogh the separation was both painful and bitter, and he saw it as yet another failure. In September he decided to take lodgings alone in the province of Drente in the northern Netherlands. He remained there until the end of December; then he moved back to his family at Nuenen, a village near Eindhoven in Brabant, to which his father had in the meantime been transferred.

on several occasions to Theo. In his last letter, of 25 March 1885, he wrote despondently: "Vincent told me that his dejection has no particular reason." And how could he have helped someone who did not want to be helped? On the day after he wrote this letter, the old Pastor died of a stroke on his way home from a walk.

In order to get over the loss of his father, which affected him deeply, Van Gogh threw himself even more into his work. And that was how he spent the summer months of 1885. Before long the paintings were being stacked up in his studio, most of them still lifes. But in September a scandal shattered peaceful village life. Gordina de Groot, a peasant who had often posed for Van Gogh, was expecting a child. Malicious tongues soon decided who the "guilty party" was: it could only be Van Gogh, the rebel, the amoral outsider, they insisted. The accusations appear to have been entirely unfounded, but the Catholic priest of Nuenen forbade his congregation from acting as models for the artist. As a result of this situation, which he experienced as unfair slander, Van Gogh left Nuenen at the end of November and moved to Antwerp. There he attempted to re-establish contact with the circles of "official" art.

Antwerp: growing in confidence

In Antwerp, Van Gogh enrolled at the École des Beaux-Arts, but was not satisfied with the teaching and visited the studio of Franz Vinck in the evenings, where he often worked until the early hours of the morning. This obsession with work, his excessive smoking and a poor diet, weakened him by the day. At the beginning of 1886 he became seriously ill, but fortunately recovered quickly.

He wanted to make progress with his artistic training but soon rebelled against the irrational academic system and quarreled with his teachers. The committee responsible for the basic training ultimately failed him "be-

cause he cannot draw." This verdict, of which Van Gogh learned nothing because at that time he was already in Paris, related to a portfolio of drawings he had presented for admission to the next stage of the course. The examination had taken place in February. Even beforehand Van Gogh knew what the result would be: "Just yesterday I finished a drawing that I've made for the competition in the evening class. It's the Germanicus figure that you know. Very well—I know for sure that I'll certainly come last, because all the drawings by the others are the same, and mine is completely different. But I saw the drawing that will be considered the best executed— I was sitting just behind—and it's correct, it's anything you like, but it's DEAD and so are all those drawings that I saw."

Van Gogh's duty lay with another kind of art that was both more lively and more educated. In his voluminous correspondence we find references to all the great masters of the past; and these are by no means simply mentions in passing, but well-founded and often original analyses of their artistic intentions, techniques, and style. The artist he preferred above all was Rembrandt, "the magician," perhaps partly because he was also Dutch, but without doubt also because Van Gogh was fascinated by the intensity of his painting; he felt they had much in common.

Paris again: intoxicated with color and freedom

At the end of February Van Gogh suddenly decided to leave Antwerp and at the beginning of March arrived in Paris. He had scarcely stepped off the train when he sent a message to his brother Theo, who by now was in charge of a small Goupil gallery on Boulevard Montmartre, asking him to meet him in the Salon Carré des Louvre. Theo hurried to the rendezvous, and after a short discussion he took his brother back to his small apartment.

In Paris Van Gogh frequented the studio of Fernand Cormon, a painter who was very fashionable at the time. Here he met Henri de Toulouse-Lautrec, while Theo pointed out to him the representatives of Impressionism: Claude Monet and Camille Pissarro, Edgar Degas and Georges Seurat, Pierre-Auguste Renoir and Paul Signac. Not surprisingly, Van Gogh's works from this period, consisting mainly of self-portraits, still lifes and flower pictures, reveal clear echoes of the technique and colors of the Impressionists. In June Vincent and Theo moved to a larger apartment in Montmartre at 54 Rue Lepic, where Vincent even had a studio. At first things went well. He was able to devote himself to his art, and even his health improved considerably. But gradually he became unbearable again; his intolerance ultimately made life with his brother impossible, though the latter was prepared to put up with quite a lot. During the winter of 1886–1887 Theo became ill and was confined to his bed for some time. In spring, when the weather improved, so did the relationship between the brothers. Theo, who had fully recovered, was able to return to work. In the meantime, Van Gogh turned his attention to painting outdoors, accompanied by his new friend, the painter Émile Bernard, whom he had met in Cormon's studio, where Bernard taught. In Paris that spring, a happy time for him, Van Gogh was a frequent guest at Le Tambourin, a cabaret on the Boulevard de Clichy. The proprietress was the Italian Agostina Segatori, who had modeled for Degas. There Van Gogh organized an exhibition together with Paul Gauguin, whom he had also met recently, as well as Toulouse-Lautrec, Bernard, and the painter Louis Anquetin. The spring and summer passed without incident. Van Gogh was increasingly wrapped up in his work. During this period he painted *In the Café: Agostina Segatori in Le Tambourin*, numerous self-portraits, including his *Self-Portrait as an Artist*, and the famous *Portrait of Père Tanguy*, an old paint dealer in whose shop Van Gogh liked to buy his materials.

Van Gogh and Japonisme

It was in Van Gogh's year of birth (1853) that Japan first resumed trade relations with foreign countries again. Young Vincent had had contact with Japanese art through reproductions in magazines. He collected these illustrations, and in Antwerp he started to purchase a few Japanese prints that he later hung in his studio in Rue Lepic—and that would later become part of the magnificent collection in the Van Gogh Museum in Amsterdam.

Van Gogh adopted the principles of Japanese art for himself, especially its close, subtle, and humble attention to nature. Thus he would later say that the south of France was the Japan of the West. "Look, isn't it almost a true religion which these simple Japanese teach us, who live in the midst of nature, as if they themselves were flowers?"

From Japanese artists he adopted the unconventional and bold choice of colors and compositions consisting of simple areas of pure color, a style that, while abandoning the rules of naturalistic representation, was based on a sensitive awareness of the natural world. However, he avoided everything decorative, and he used black, which was not used in Japanese color prints.

Under the southern sun

In time Van Gogh found Paris exhausting and even disappointing, and so in February 1888 he decided to travel to Arles in Provence, where he initially took a room in the Pension Carrel. A very productive and creative period followed, in which he worked intensively: in the warm light of the south he painted the blazing landscapes of the rural environs of the town, the sumptuous blossoms of spring, the fields of corn, and the verdant gardens.

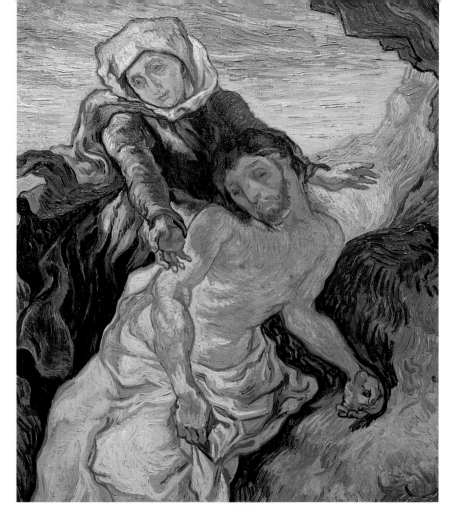

Pietà (after Delacroix),
September 1889,
Van Gogh Museum,
Amsterdam

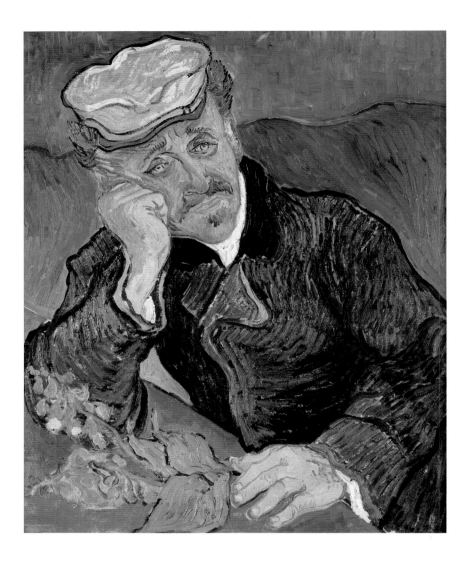

*Portrait of Dr. Gachet
June 1890, Musée
d'Orsay, Paris*

In May he rented a four-room apartment at 2 Place Lamartine. Here he hoped to be able to realize an old dream: he wanted to gather around him a community of painters. His first (and only) guest was Paul Gauguin, whom Van Gogh welcomed to Arles on 20 October. But after just a few weeks the relationship between the two artists became strained. Their characters differed and almost daily there were endless quarrels about artistic questions that became progressively more hostile because deep-seated differences of opinion came to light. And then, on 23 December 1888, an incident occurred that has become an inescapable part of the Van Gogh story: he attacked his friend with a cut-throat razor and then later that night, in a rage, he cut off part of his own left ear, wrapped it in newspaper, and took it to a prostitute "as a gift." Van Gogh had almost bled to death by the time he was admitted to hospital. Theo, whom Gauguin had notified by telegraph, set off as quickly as possible for Arles.

In spite of his miserable state—and especially his mental condition—Van Gogh made a relatively quick recovery and was able to leave hospital on 7 January 1889. He started painting again but his sleep was troubled and be began to have hallucinations, and in early February he was admitted to hospital again. He had scarcely left the hospital when, at the beginning of March, a petition by eighty citizens submitted to the mayor of Arles resulted in the painter being compulsorily admitted again. By April he had recovered sufficiently to be able to take up his paintbrush again. He worked doggedly, painting the gardens and plants, and began reading again; gradually be began to lead a relatively normal life.

Saint-Rémy: working so as not to die

On 8 May Van Gogh became a voluntary patient in the psychiatric hostpial at Saint-Paul de Mausole near Saint-Rémy. What contributed to this decision was the fact that Theo had married a short while previously and Vincent did not want to be a burden to him any longer. Theo ensured that his brother had two rooms, in one of which he was able to set up a studio. Van Gogh was also permitted to go out to paint, albeit only when accompanied by his nurse, Jean-François Poulet. No specialist was engaged to determine the nature of Van Gogh's illness.

As always, he painted a great deal: interiors, views of gardens, landscapes in the vicinity, and flowers; he also painted a great deal from reproductions sent to him from Paris. It was during this period that he produced his *Wheatfield with a Reaper*, "a picture of death such as the great book of nature offers us." Even in this time of suffering, his mind was constantly occupied. Paul Signac, the last friend to visit Van Gogh, also reported on this desperate will to live: "I have seen Vincent again, most recently in the spring of 1889 in Arles. At that point he was in the municipal hospital. He spoke the whole day about painting, literature, and socialism." Van Gogh endeavored to find a painting technique that met his requirements entirely, a speed of application of the paint that he would never achieve. "He was without doubt an outstandingly good colorist, but he was not the 'colorist of rank who had never been seen before,' which he dreamt of being; and with heroic modesty he was satisfied with being his exhausted and bold forerunner" (Francesco Arcangeli, 1952).

Late, fleeting pleasures

The violent crises with which Van Gogh had constantly to struggle increasingly wore away his strength; in a dreadful frenzy in December 1889 he even attempted to swallow paint. But at times his mood brightened again, as if after a thunderstorm, and he returned to work with fresh courage and hope. In January the art

critic Albert Aurier published in the *Mercure de France* the article *Les Isolés: Vincent van Gogh* (The Loners: Vincent van Gogh) about his painting, and in February Theo informed him that the sister of an artist friend, Eugène Boch, had purchased the painting *The Red Vineyard* for 400 francs. Aurier's article was the only publication about Van Gogh to appear during his lifetime. The *Mercure de France* was one of the most important French magazines and focused its attention specifically on Symbolism. Initially, Van Gogh felt that the essay endorsed his work, but shortly afterwards he asked Theo to persuade the critic not to discuss his painting any further because he found it all too painful, fearful he would not be able to live up to the public interest aroused by the article. On 17 May 1890 he was fully recovered and traveled to Paris, where he spent three days with Theo. He met his sister-in-law Johanna and his little nephew, who had been born on 31 January and who had been given the names of his uncle, Vincent Willem. The brothers fell into each other's arms and wept in the room in which the infant was sleeping.

Illness or loneliness? A tragic epilogue

From Paris Van Gogh traveled to the idyllic village of Auvers-sur-Oise, which lies about an hour by train from the capital. This was where Dr. Gachet lived, a doctor and painter who counted Pissarro, Paul Cézanne and other Impressionists among his friends, and who had expressed his willingness to look after the artist. Van Gogh was fascinated by the atmosphere of Auvers-sur-Oise, with its undulating fields and thatched cottages, which made it very different from Provence. He immediately set to work and painted the houses in the little town, the gentle hills in the vicinity, and the endless cornfields under the stormy sky, as well as a number of portraits, including one of Dr. Gachet. "Doctor Saffron,"

as the doctor was called because of the color of his hair, studied nervous diseases.

During this period Van Gogh produced over eighty paintings, an average of one and a half per day. He now had a new model as regards style: the Symbolist painter Pierre Puvis de Chavannes. "As to figure, the portrait of a man by Puvis de Chavannes has always remained an ideal for me, an old man reading a yellow novel, with beside him a rose and watercolor brushes in a glass of water." He also praised the artist's paintings in which the essence of man and nature are most simply expressed, in a way that he himself always aimed to achieve.

On 8 June Theo visited him accompanied by his wife and their little son, and they spent the day together. After another brief detour to Paris on 6 July Van Gogh returned to Auvers; he was no doubt saddened at the news that Theo would not be able to spend the holidays with him as planned. He was also exhausted by hectic city life, to which he was no longer accustomed. If we read his letters from this period attentively it becomes clear what a dangerously agitated state he must have been in. On the afternoon of 27 July, a Sunday, Van Gogh left his quarters in the guesthouse run by Monsieur and Madame Ravoux. Under his arm he was carrying his easel, and in his pocket he had a pistol. He went into the cornfields as he did every day, apparently to paint there. He may well not have known at this point what he planned to do with the pistol. He probably made the decision to put an end to his life while searching for a new subject for a painting in the sunshine. Van Gogh shot himself directly in the region of his heart with the revolver, but the bullet was deflected by the diaphragm and remained stuck there. He returned to the guest house and went up to his room. Monsieur and Madame Ravoux missed him at supper and went upstairs. They realized what had happened. Van Gogh ex-

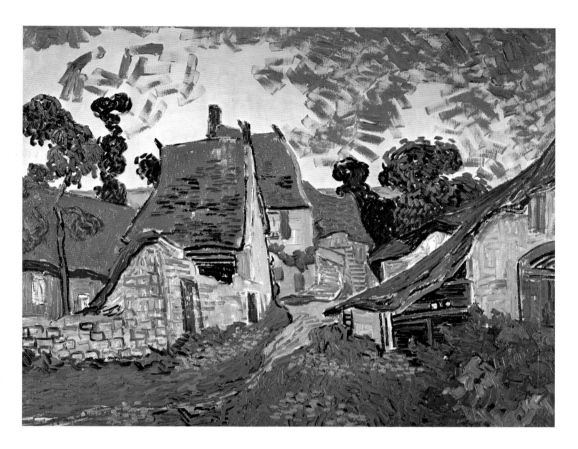

Village Street in
Auvers, July 1890,
Ateneumin
Taidemuseo, Helsinki

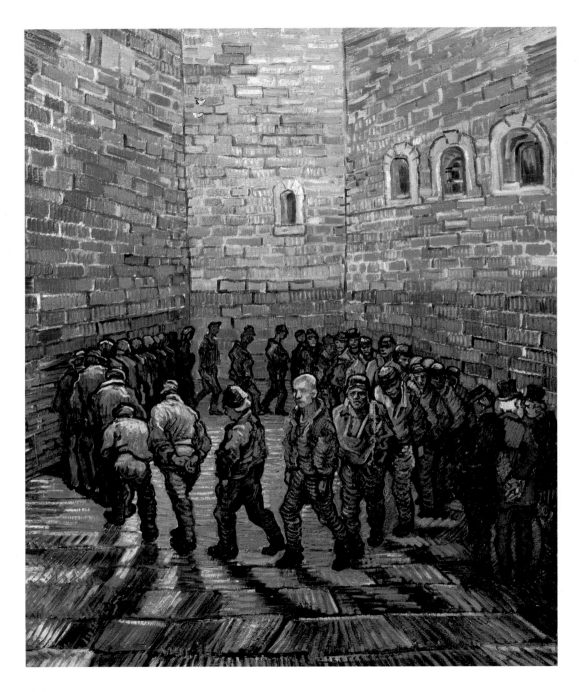

plained to them in a calm and friendly manner that he had wanted to kill himself. Dr. Gachet hurried round, treated the wounded man and immediately informed Theo, who arrived in Auvers the next morning; his brother's condition by this time was hopeless. The artist died during the night of 29 July, having sat all day chatting and smoking a pipe in his bed.

Only six months later in Utrecht, on 25 January 1891, Theo followed his brother to the grave. Today they lie side by side in the little graveyard in Auvers, between cornfields and the silvery branches of the olive trees. The two graves, marked by two plain gravestones, are covered with a single cloak of ivy—as if the brothers were still embracing each other.

Prisoners Exercising, 1890, Pushkin Museum, Moscow

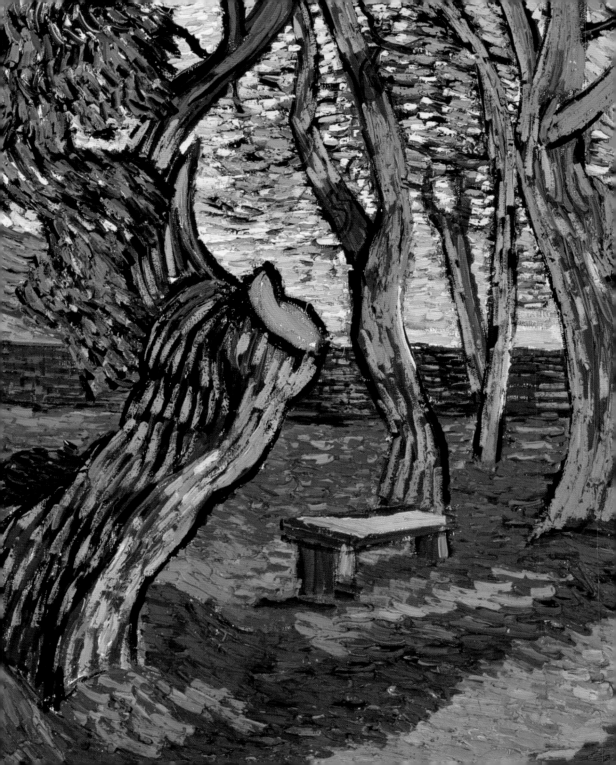

WORKS

The Sower (after Millet)

Early 1881

Pencil, ink and wash on wove paper, 48 x 36.8 cm
Van Gogh Museum, Amsterdam

At the age of twenty-five, Vincent van Gogh was troubled and dissatisfied both in his professional and his private life. It was in The Hague that he first came into contact with art: in 1869 his Uncle Cent had found him a job with the art dealers Goupil. Though initially he was a model employee, over the years he became increasingly unhappy and preferred visiting museums. When his position with Goupil ended in March 1876, Van Gogh began a period of wandering. He first settled in southern Belgium, where he worked as a lay preacher for a church organization in the mining area near Mons. It was here that he began to draw again, this time with passion and determination. After he was dismissed from his ministry because of his "excessive enthusiasm," in October he went to Brussels in order to learn correct anatomical and perspectival drawing. He sought "an essentially artistic environment ... after all, how can you learn to draw if nobody shows you how?" During the course of the next six months, and keen to put his recent experiences behind him, he worked with great intensity, and his discussions with his new friend, the painter Anthon van Rappard, were equally intense. His brother Theo now sent him a small amount of money each month.

At this early stage his knowledge of art was based largely on the works he had learned to appreciate at Goupil. He was particularly impressed by the prints of the Socialist-Romantic artists, notably Jean-François Millet, who was to remain an important inspiration for Van Gogh throughout his life. As a self-taught artist, Van Gogh began by copying other works and also illustrations in books and magazines; this, at least, made him "feel he was of some use," and he resolved to improve his technique. In a letter to Theo dated 9 December 1877, he wrote: "Once I have mastered the art of drawing or painting in watercolors or etching, I can return to the land of the miners and weavers, to achieve after nature more than before. First, though, I must become more skilled." The pictures he created at this time did not stray far from the models he admired so fervently. The sower is a motif that was close to Van Gogh's heart: an emblem of the farmer's life, it simultaneously refers to the biblical metaphor of the preacher "sowing the seed" of God's Word. Van Gogh was not a Romantic, however; he was molded by a deeply felt respect for the everyday, which went as far as a total identification with subjects that he saw in terms of a troubled Christian spirituality.

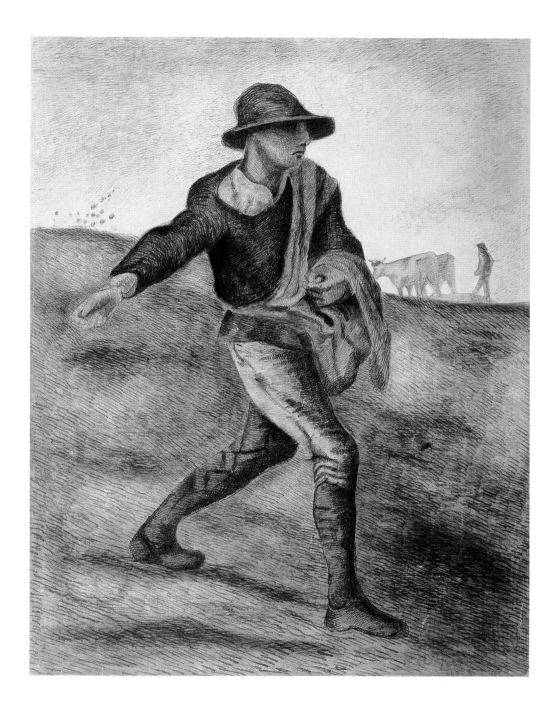

Sorrow

April 1882

Pencil, pen and ink, 44.5 x 27 cm
Walsall Museum & Art Gallery, Walsall

From the beginning of 1882, Van Gogh attempted many small-format views of The Hague, most of them drawings in pencil or pen, though he also painted a few watercolors. The drawing entitled *Sorrow* is one of the best-known works from this period. In firm, tense lines he captures the suffering body of Sien, the woman who had played a short—but important—role in his life from the beginning of that year. Clasina Maria Hoornik, known as Sien, was a prostitute aged about thirty (and therefore considerably older than he was). Her body already looks worn out by poverty, disease, and alcoholism. She was the mother of a young child and pregnant with her second child at this time. Van Gogh met her in late January 1882 and took her in. She worked as a model for him (for roughly sixty drawings and watercolors) and Van Gogh took care of her and her child. Before the next child was born, he went to great trouble to prepare a room for the birth. The newborn baby aroused a great tenderness in him: "It is a strong, powerful emotion that overcomes a man when he has sat next to the woman he loves with a little child in the cradle beside them." For him, "woman is a religion," as he phrased it with reference to the French writer Jules Michelet. He longed to share his life with a woman, but had experienced nothing but rejection. When he found Sien, he thought he had reached his goal: "She and I are both unhappy people who have joined forces and shoulder their burdens together." Sien was a burden, but she was also a pictorial motif that brought together art and reality. Without a hint of irony, he read her countenance as a godly symbol of the plowed field, of sowing and reaping, a metaphor that would continue to exercise him in his efforts to become a painter who was respectful to the reality of humankind. He first drew the outlines of her body in ink, then reworked these in pencil, adding small areas of ink wash. The drawing is inscribed "Comment se fait-il qu'il y ait sur la terre une femme seule—délaissée / Michelet" ("How can it be that there is a woman alone in the world—neglected / Michelet").

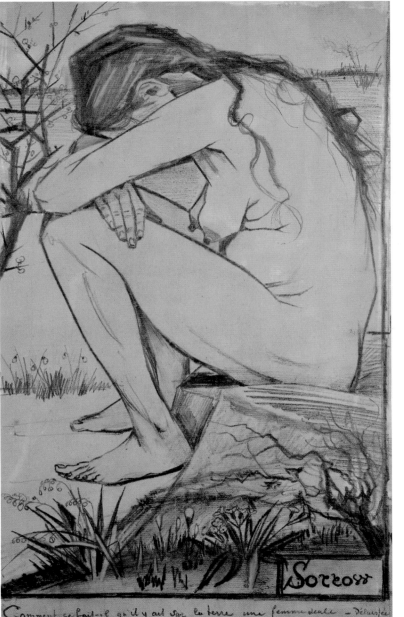

Comment se fait-il qu'il y ait sur la terre une femme seule — Délaissée
Michelet

Beach with People Walking and Boats

September 1882

Watercolor, gouache and charcoal on paper, 27.8 x 46 cm
Private collection

Amsterdam is connected to the seaside resort of Scheveningen by a long promenade: for three kilometers it follows a famous beach of fine sand set against a background of high dunes alternating with flat stretches. In the 1870s some representatives of The Hague School of painting, seeking a connection with the great tradition of the seventeenth-century landscape painting of the Netherlands, focused increasingly on maritime motifs. Some of them eventually moved to the dunes, where they lived in close proximity to the sea. Van Gogh's lodgings were not far from the beach, and he did not mind working in the open air, even when the weather was bad. In a letter dated 26 August 1882, he wrote that he had been to "Scheveningen many times ... And came back with two small seascapes. There's already a lot of sand in the one, but with the second, when there really was a storm and the sea came very close to the dunes, I had to scrape everything off twice because of the thick layer of sand completely covering it. The wind was so strong that I could barely stay on my feet and hardly see through the clouds of sand."

In another letter to Theo from this period, Van Gogh records the pleasure he took in sketching the people he saw on the beach, the fishermen with their boats or people just out for a walk. And watercolor proved particularly effective for capturing the wind-swept animation he wanted, the seemingly spontaneous impression of both movement and light: "What a wonderful thing watercolor is to express atmosphere and distance, so that the figure is surrounded by air and can breathe in it..."

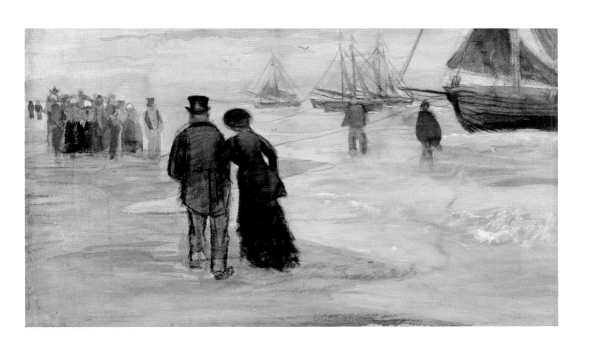

The Potato Eaters

April 1885

Oil on canvas, 82 x 114 cm
Van Gogh Museum, Amsterdam

This painting is the first by Van Gogh that he himself described explicitly as an independent work of art; in several letters he referred to it as "the painting." In October 1887 he wrote to his sister Wilhelmina from Paris: "Among my own works, I consider the picture of the potato-eating farmers that I painted in Nuenen to be, *après tout*, the best that I have ever painted." Van Gogh had to work hard to create this masterpiece. In early April he made studies for the individual figures and a composition sketch. Around 11 April these were followed by a sketch in a letter, and a few days later by a sketch of the composition. This was followed by the first version of a painting, which he made into a lithograph in the course of a single day and, finally, the second version (illustrated here). This version gave him the feeling that he had at last created a work that could stand comparison with those of Jean-François Millet.

These farmers, he observed, were "exceedingly ugly and repulsive," making them all the more true to life; they are so expressive that they have become true icons of a social form of art, symbols of a moral integrity of the kind that emerges from the struggles of everyday life. Shortly before completing the work, he wrote to Theo: "Those who prefer to see farmers as sweet can stick to their position. I, on the other hand, am absolutely convinced that one achieves better results if one paints them in their crudeness rather than introducing conventional complaisances." In another letter, he wrote: "At the moment, I don't simply paint while it is light, but continue in the evening by lamplight in the huts, when I can hardly distinguish what is on my palette, because I want to capture something of the peculiar lighting effects of the evenings." And later: "I have made a great effort to make the viewer consider that these people, who eat potatoes by the light of their lamp, have dug the earth themselves, using the same hands with which they reach into the bowl." He constructed the furrowed modeling of the face using nuances of color. During the previous year, he had already stated that "color itself expresses something," and he had been able to use Gustave Courbet's portraits to study how color could be employed as a vehicle for expression, not simply for the naturalistic imitation of nature.

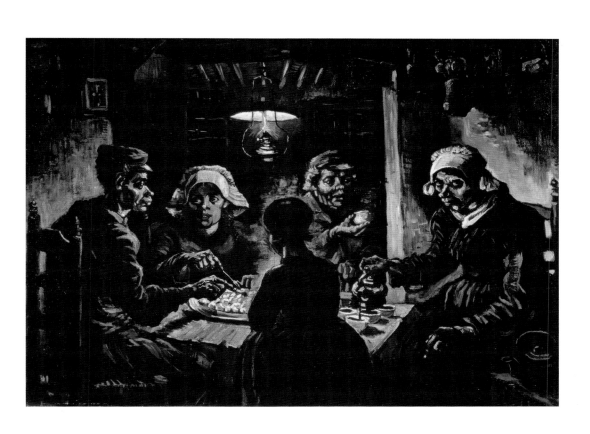

Still Life with Bible

October 1885

Oil on canvas, 65 x 78 cm
Van Gogh Museum, Amsterdam

Among the many highs and lows, there were also phases of intensive and productive work in 1885. At times Van Gogh's zest for life was so great that he wrote to his brother: "Come on, lad, come and paint on the heath, in the potato field, come here and let's walk along behind the plow and the shepherd—come and look into the fire, too." But the unforeseen happened on 26 March: their father died quite unexpectedly. For Vincent, the unyielding and reserved Theodorus van Gogh had given rise to terrible inner conflicts—he had even attempted to study theology in Amsterdam in order to please his father. Now, quite suddenly, he found himself without his father's moral and spiritual authority. In this still life, painted in just one day, an extinguished candle in the candlestick that had belonged to his father is a very personal *memento mori*. It is a still life through which Van Gogh reflected on his complex relationship with his parents. The Bible, that colossus in the cultural heritage of humankind, is provocatively juxtaposed with Émile Zola's recently published novel *La joie de vivre*, the implicit contrast between these two works being expressed visually through color.

The lemon-yellow of the novel also indicates that Van Gogh wanted to challenge his brother's belief in traditional tonal painting; Theo continued to see this as the only path one could follow, whereas Vincent insisted it was a dead-end. Zola's novel stands for a vision of a life that is entirely committed to truthful emotions; he adhered closely to the concrete reality of life and was committed to Positivism. The iconography of the still life also makes clear that Van Gogh positioned himself in the painting tradition of the Netherlands, which during the seventeenth century had been one of the leading schools of European art.

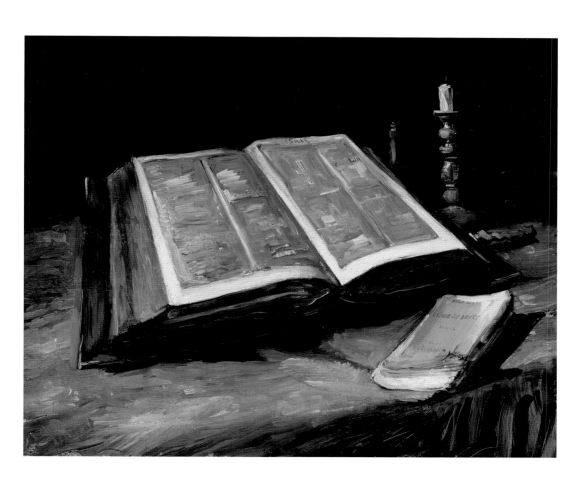

Autumn Landscape with Four Trees

November 1885

Oil on canvas, 64 x 89 cm
Kröller-Müller Museum, Otterlo

In November 1885, Van Gogh painted several works on the subject of the slow, glorious decay of nature that takes place during the fall, images characterized by subtle combinations of yellows, oranges, browns, gray-greens. The wonderful painting shown here was executed in just three days. Excitedly, he wrote to Theo: "You know the three pollard oaks at the end of the garden at home—I worked away at them for the fourth time. I'd sat in front of them for three days with a canvas the size of that cottage, say, and the peasant cemetery you have. The thing was the canopies of Havana-coloured leaves—how to model them and get the form, the colour, the tone. Then one evening I took it with me to an acquaintance of mine in Eindhoven, who has quite an elegant drawing room (gray wallpaper—furniture black with gold), where we hung it. ... never before have I felt *such* a conviction that I'll make things that work, that I'll succeed in calculating my colours such that I have it in my power to create an effect."

The landscape reveals a great tenderness and deep melancholy: the trees appear to be still alive, about to go into hibernation, in surroundings that breathe gently. Even the small figure of a woman walking into the distance does nothing to disturb the tranquility. This painting is one of the most successful Van Gogh executed at this time, as early critics recognized. Jacob Baart de la Faille, for example, wrote: "His work is the incarnation of reality. He is the grand master of a stirring naturalism" (*L'époque française de Van Gogh*, Paris 1927).

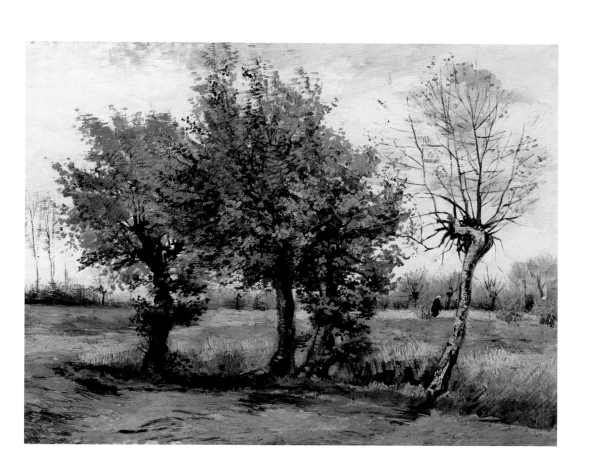

The Dance Hall

December 1885

Black and colored chalk on wove paper, 9.2 x 16.3 cm
Van Gogh Museum, Amsterdam

His return to his parents' house in Nuenen in 1883 shows that Van Gogh had not felt suffi-
ciently prepared for the oppressive solitude he had had to face. But he was clearly not sat-
isfied with working alone in nature near Nuenen, either, even if he had discovered Eugène
Delacroix for himself at this time. He had reached a parting of the ways: "I must choose
between a workspace without work here, and work without a workspace there. I have opted
for the latter. And I have done so with so much pleasure and delight that it feels like a
retour d'exil [return from exile]." It was through Delacroix that Van Gogh came to Peter Paul
Rubens, and so the next station on his life's journey was Antwerp. He arrived in late Novem-
ber 1885 and had the opportunity to marvel at numerous originals of paintings by the great
master of Flemish Baroque. Amongst other things, he was fascinated by the way in which
Rubens managed to paint a face with "brushstrokes in pure red."
Even though Van Gogh was not in good physical health, his emotional state appears to have
improved a little. He continued to develop his theoretical position during these months, to
approach a vision of art, even if, in terms of technique, he was not yet able to apply this in
his painting. "Perfection" for him was not achieved through a purely descriptive recording of
the concrete (as he had done in hundreds of "studies"), but through a synthesizing of colors
that could be achieved only by capturing what he called the "soul," the inner nature, of ob-
jects. Though fundamentally a realist, Van Gogh anticipated the positions of the artists of
the avant-garde.
In Antwerp, other sources of inspiration slowly took the place of the venerated Jean-
François Millet. Even if he considered them banal as a motif, in dance halls, and in people
amusing themselves by dancing, Van Gogh found music and an atmosphere that appealed
to him.

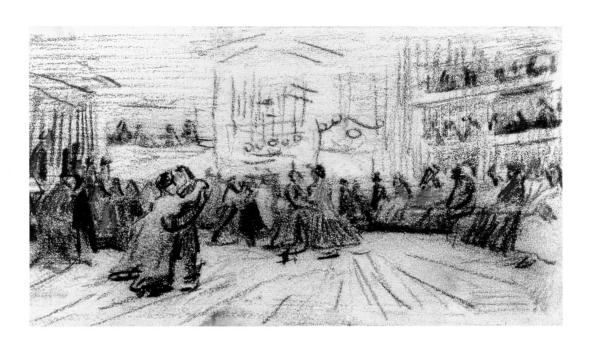

Self-Portrait with Dark Felt Hat

1886

Oil on canvas, 41.5 x 32.5 cm
Van Gogh Museum, Amsterdam

Van Gogh painted 230 paintings during the two years he spent in Paris (1886–1888):
this was the most productive phase of his life. There are at least twenty-five self-portraits
among these paintings. If one considers that there are about ninety self-portraits in total in
Van Gogh's oeuvre, it becomes clear that scrutinizing his own image—and increasingly his
own emerging personality as an artist—was a priority for him during his time in Paris, after
having spent so long depicting the faces of other people. An ironic skull with a lit cigarette
between its teeth was a first, highly interesting, attempt, created during his winter stay in
Antwerp. One can view this painting in different ways: perhaps as a joke among students at
the art academy in Antwerp, as a sort of ironic take on the exercises in anatomical drawing
that were part of the academic program, or even as a comic *momento mori*, a prompt to
contemplate one's own physicality and mortality.

He had spent many years living the life of a hermit and adapting to the life-style of rural
populations. Finding himself confronted with urban life once again, he underwent dental
treatment in order to improve his appearance. In the self-portrait shown here, Van Gogh
can be seen almost entirely *en face*, his posture quite relaxed; there is almost a note of
academic painting in this pose, though the intense gaze makes clear how much he admired
Rembrandt and Eugène Delacroix. In late 1887, he painted several studies of skulls, prob-
ably without symbolic undertones, but not without connections to this last self-portrait
from his time in Paris.

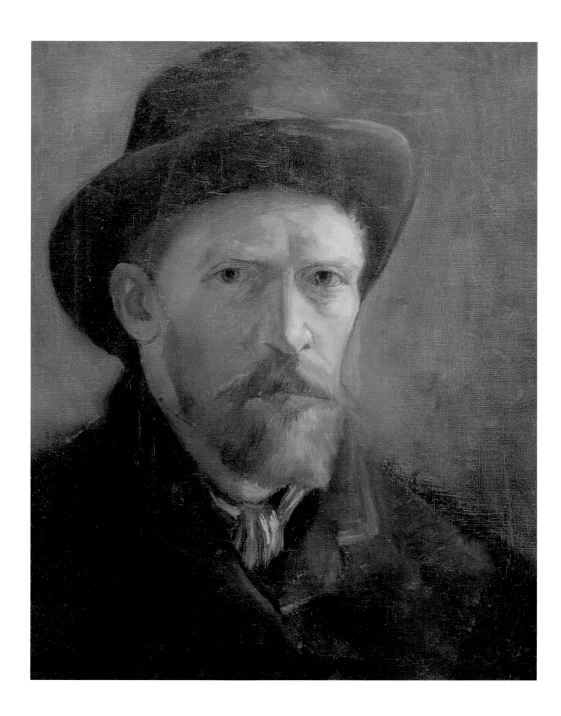

Vase with Autumn Asters

Summer 1886

Oil on canvas, 61 x 46 cm
Van Gogh Museum, Amsterdam

In Paris Van Gogh painted more than forty flower still lifes that are among his most suc-
cessful works. Research has interpreted these paintings as the artist's attempt to demon-
strate that he was now the "master of color" and able to employ what he had imagined
three years previously—his "own palette." He still started from concrete manifestations of
nature, but paid more attention to avoiding purely representative images in order to allow
the colors—pure, contrapuntally applied colors—to speak for themselves, to have a life of
their own. He pursued the thought that "the stronger the color in the paintings is, the more
enthusiasm there is for life."

The eighth (and last) exhibition of the Impressionists also took place in 1886. The impending
crisis of Impressionism could already be sensed at this exhibition of works by artists such
as Georges Seurat, Paul Gaugin, and Claude Monet, who, in his idyllic hermit's existence in
Giverny, was already moving towards Symbolism with his extraordinary paintings of water
lilies. At this time Van Gogh was so enthusiastic about the work of the painter Adolphe
Monticelli, an artist from Marseille who died on 29 June 1886, that he wrote: "Sometimes
it seems to me as though I were continuing his life in myself." It must be remembered that,
despite the coloristic beauty of the flower still lifes, they were, amongst other things, "five-
finger exercises" for Van Gogh.

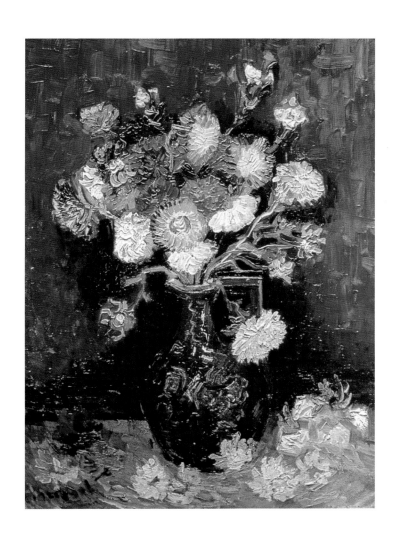

The Hill of Montmartre with Stone Quarry

1886

Oil on canvas, 56.2 x 62.5 cm
Van Gogh Museum, Amsterdam

This view shows the limestone quarry on the northern slope of the hill of Montmartre in Paris. Having supplied Paris with limestone of the highest quality for several centuries, the quarry had now been almost entirely abandoned. Symbolic references, such as those that characterized his representations of the windmills at Nuenen, for example, are entirely absent here. Van Gogh interpreted the Dutch windmills as a metaphor for "the mills of God." This painting, however, is simply a snapshot of a very well-known place, where the mills would not remain for much longer, and also a reminder of the disappearing past. A series of nine views of the hill of Montmartre by the engraver Auguste Delâtre, reproduced in the journal *L'Artiste* that same year, served as inspiration for Van Gogh, even though he almost certainly painted directly from nature here, as he did with the other views of this quarter. Together with two other views of the mills on the hill of Montmartre, this painting reveals a very careful study of the landscape's peculiarities. The small figures Van Gogh positioned in the landscape are a well-known and popular pictorial element used both to animate a scene and to provide scale. The coloring remains realistic here, and is similar to that of comparable views of the area by Camille Corot, an artist much admired by Van Gogh. And, as in Corot's paintings, the light washes gently over the scene.

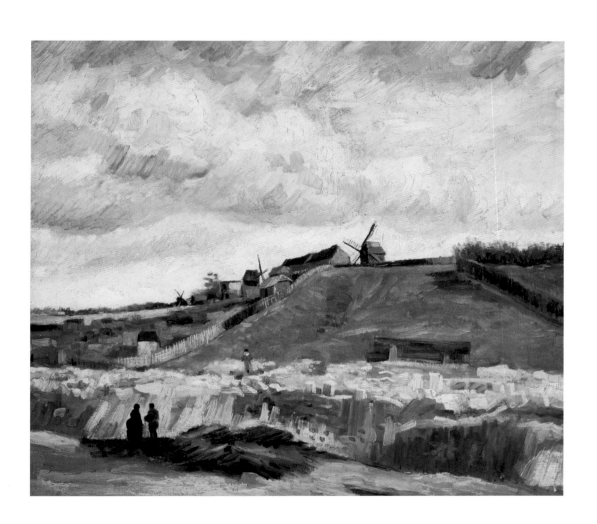

*The Hill of Montmartre
with Stone Quarry
(details)*

In the Café: Agostina Segatori in Le Tambourin

Early 1887

Oil on canvas, 55.5 x 46.5 cm
Van Gogh Museum, Amsterdam

Here Van Gogh shows that he adopted from the Impressionists not just a painting technique, but also an interest in motifs taken from what the poet Charles Baudelaire called "la vie moderne" (everyday modern life). With these scenes, Vam Gogh distanced himself from his representations of peasants, which are timeless and other-worldly. He now took an interest in urban life, in the habitués of cafés, bars, and dance halls. And this was not just because of the influence of the artists he met in Paris, such as Henri de Toulouse-Lautrec. Previously he had trouble finding male and female models, so that he had had to pay the peasants of Nuenen in order to be allowed to paint them. In Paris, by contrast, he had no trouble finding a willing model: Agostina Segatori, who had already sat for Camille Corot, Jean-Léon Gérôme, and Edgar Degas, and who is probably the subject of the artist's small number of nudes. She was the proprietress of a café, restaurant, and cabaret in which Van Gogh frequently ate and once exhibited his works. He painted this portrait of Agostina sitting at a little table in the café on the occasion of an exhibition there in the spring of 1887—a table that looks very like a tambourine, the instrument after which the establishment was named. Cool tones dominate the bluish light, which is disrupted by the bright red of the table and the unusual headdress. A large Japanese picture hangs on the wall. This painting is one of a broad series of contemporary portraits of women that can be understood as metaphors for a divergence from, and challenge to, social norms. They include *A Glass of Absinthe* by Edgar Degas, executed around 1876. Here, however, Van Gogh wished to communicate "an impression, a feeling," even if a slight sense of sadness is to be felt, while an inner emptiness is much clearly expressed in Degas's painting.

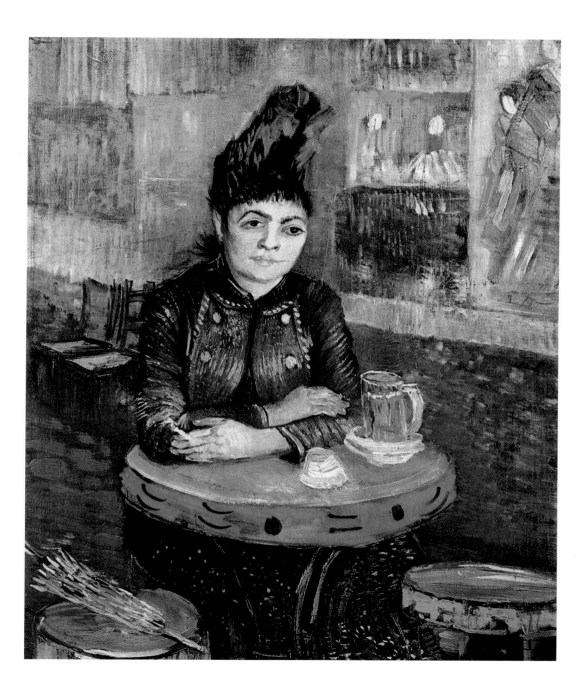

Vegetable Gardens in Montmartre (La Butte)

April–June 1887

Oil on canvas, 81 x 100 cm
Van Gogh Museum, Amsterdam

"The air in France brightens the thoughts and is good for you," wrote Van Gogh; "A refresh-
ing wind blows here." This painting is one of a number of works that would, as he recog-
nized, be difficult to sell, but that were characterized by such a cheerful mood that he
imagined them in a country house or a dining room. During the spring of 1888 this land-
scape was shown, together with a few other paintings, at the Salon des Indépendants in
Paris. Van Gogh was pleased with the result and intended to donate the painting to the
museum for contemporary art in The Hague "because we have so many memories of this
city." The museum bought paintings by other artists at the time and Van Gogh hoped that,
through the donation, his works would be exhibited together with theirs. The critic Gustave
Kahn was not enthusiastic, and in a review of the Salon des Indépendants criticized Van
Gogh for not paying enough attention to the harmony of his colors, and it is true that his
painting is rooted in lively complementary contrasts. Van Gogh remained unperturbed:
"It is not possible to be at the Pole and at the Equator at the same time. One has to decide:
I hope to do so, and it will probably be color."
At this time he was also increasingly interested in perspectival effects, and so he selected
for this painting a view that draws attention in particular to the gardens in the foreground.
He painted them in unmixed, contrasting colors. In the background, we can see the city,
while the character of the foreground is almost that of a rural idyll. This contrast—between
the city and country world of modest little houses without paved roads and with inhabitants
the painter referred to as the "little people"—was characteristic of his time in Paris. The
upper part of the painting is dominated by clayey painting, which begins to open up to the
increased luminance of white, blue, and green tones.

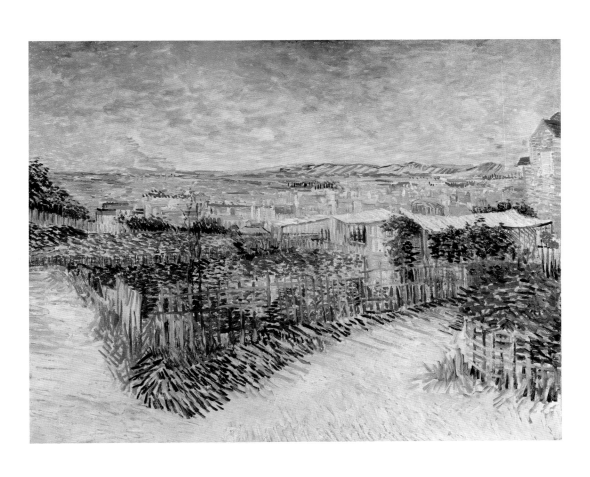

Courting Couples in the Voyer d'Argenson Park in Asnières

May–June 1887

Oil on canvas, 75 x 113 cm
Van Gogh Museum, Amsterdam

Van Gogh was not able to resist the appeal of Paul Signac's style, and began to paint landscapes made of tiny dots, particularly when he worked in Asnières. This painting, for example, clearly reveals borrowings from Signac, who must have expended a fair amount of energy in explaining his art theory to the Dutchman, sitting at bistro tables in Montmartre. Yet Van Gogh had not abandoned his individual painting style here, and the Pointillist application of color is fairly free.

One should not ignore the significance of the title, which he supplemented with "The Lovers" in a letter to Theo. This is not a simple representation of a corner of some garden in the vicinity of Paris, but the highly traditional motif of the lovers' garden. Van Gogh greatly admired *The Embarkation for Cythera* (1717) by Antoine Watteau, which he had seen on his visits to the Louvre, as well as the variations on this theme by Adolphe Monticelli, and also the poetic passages dedicated to Watteau's painting in *French Eighteenth-Century Painters* (1859–1875) by the Goncourt brothers, a work Van Gogh had read in Nuenen. The pictorial space is only hinted at, the artist concentrating entirely on the courting couples, who have been consciously moved out of the central axis of the painting. The reds and greens—the colors of passion—symbolize spring.

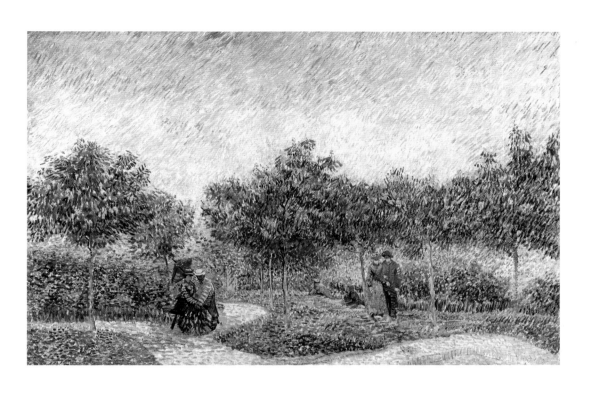

Portrait of Père Tanguy

Summer 1887

Oil on canvas, 65 x 51 cm
Private collection

The young people who bought supplies from the paint dealer Julien Tanguy liked to call the old man Père Tanguy. He came from Brittany, had taken part in the uprising of the Paris Commune, and had been imprisoned for his political beliefs. Tanguy lived according to the ideals of the Communards, who had fought for a better world, by sending letters to young, impoverished artists, feeding them, and accepting paintings as payment. Artists such as Camille Pissarro, Paul Gauguin, and Paul Cézanne visited him. Cézanne, like Van Gogh, was at times unable to exhibit his paintings anywhere but at Père Tanguy's. It was here that Van Gogh met Paul Signac and Émile Bernard, his friend during difficult times. Tanguy, along with a small group of intimate friends, would attend Van Gogh's funeral.

Van Gogh painted two portraits of the merchant, both against the same background of Japanese prints that he and Theo collected (they can now be seen in the Van Gogh Museum in Amsterdam). In his pose, Tanguy appears to want to imitate the calm and immovability of Far Eastern figures, yet the portrait reveals great emotional involvement. The viewer is drawn in by the slightly lost, almost childlike gaze of the subject, by the watery eyes of an old man. The hands, too, appear old, their wrinkles accentuated through the use of thick paint. The usual short dabs, which would not have been appropriate to this motif, are replaced by a dense application of paint using longer brushstrokes, highlighted here and there by white. Red or green dabs of color on the face and in the beard connect the figure with his background.

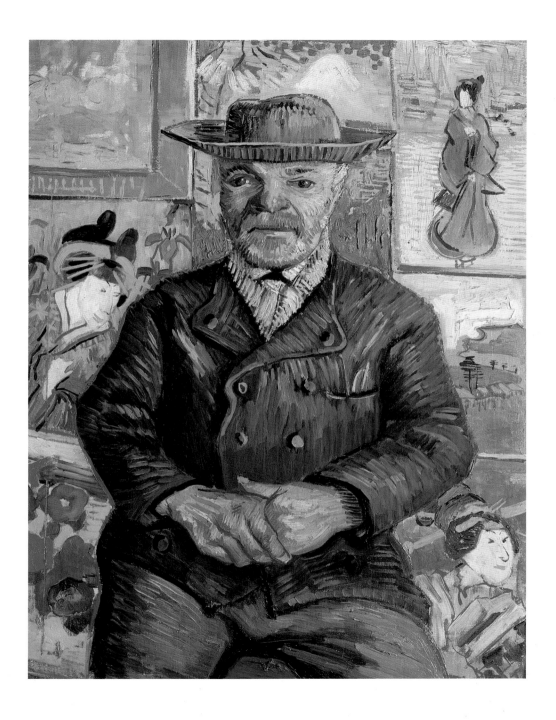

Gate in the Paris Ramp

Summer 1887

Pen, pencil, and watercolor on wove paper, 24 x 31.5 cm
Van Gogh Museum, Amsterdam

This wonderful picture is one of a series of studies of the ramparts of Paris that Van Gogh worked on during the summer of 1887. No paintings of these drawings, all of which are characterized by the same high artistic standard, are extant. The city, and its buildings in particular, was not among the artist's preferred subjects. He was more interested in its inhabitants, the "little people." "Paris is Paris, my friend, there can only be one," he wrote to a friend about the city that was actually so foreign to him, that had attracted him at first, only to leave him feeling increasingly irritated and dissatisfied. Van Gogh would get up at dawn and then wander through the city for hours. He grasped the essence of each place, from the quiet and deserted to the lively and vibrant. He appears to have made light sketches first and then continued to work on them in his studio, where detailed colored drawings like this one were created. It was not the architecture as such to which he paid attention, but the overall impression and mood of a scene.

The city walls began to be demolished in the 1880s, having been found to be insufficient protection for the city during the Franco-Prussian War. As a result, the area had been largely abandoned; prostitutes worked the area, sharing it with criminals and the very poor. On Sundays, however, the former city walls became a popular destination for the inhabitants of the working-class neighborhoods of Clichy.

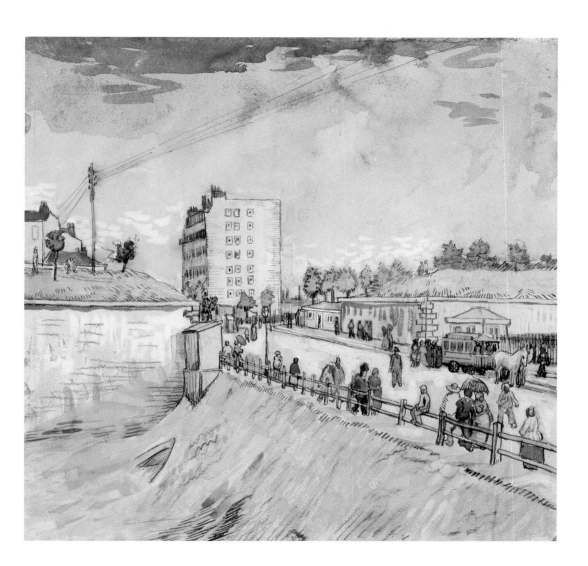

Two Cut Sunflowers

Late summer 1887

Oil on canvas, 43 x 61 cm
The Metropolitan Museum of Art, New York

Van Gogh's sunflower paintings are among his most famous. Those he painted Paris are slightly less well known than those executed during his time in Arles, however, despite the fact that they are particularly expressive. In these paintings, Van Gogh shows greater confidence and technical mastery, having experimented with new painterly forms of expression. Here, he quite naturally applies what he had achieved through his coloristic and compositional experiments. In this painting (now in New York), Van Gogh shows two cut sunflowers. One is viewed from the front, the other from the back, both set against a background of dark- and light-blue tones. The compositional arrangement is reminiscent of one of Van Gogh's key works, the still life *A Pair of Boots* (1887), which is now in the Baltimore Museum of Art. Here, too, the central pictorial idea is the positioning of two similar objects. Van Gogh was also interested in the analytical reproduction of the consistency of the petals. Iconographic points of reference to Japanese woodcuts are also to be found. Van Gogh collected Japanese prints enthusiastically because of their inexhaustible repertoire of forms. "Japanese art is in decline in its own country, but it is growing new roots in the art of the French Impressionists. This aspect, of practical interest to artists, obviously interests me more than the trade in Japan prints." For Van Gogh, the flower genre had now developed beyond the "beautiful" paintings of flower vases from the period influenced by Adolphe Monticelli. The two flower heads are absolutely in the foreground, seen so close up that they seem almost within reach. The harmonies of color in the painting shows profound knowledge of coloristic relations.

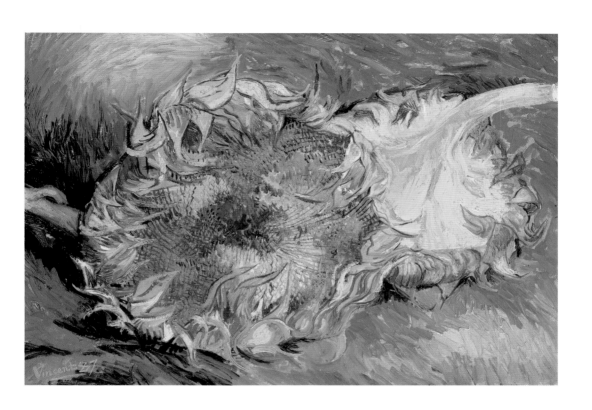

The Courtesan (after Eisen)

July–September 1887

Oil on canvas, 105.5 x 60.5 cm
Van Gogh Museum, Amsterdam

This painting adopts a motif from the cover page of an issue of the magazine _Paris Illustré_ that was dedicated to the subject of Japan. Van Gogh retains the compositional framework of a work by the Japanese artist Kesaï Eisen and positions the figure of the woman against a bright-yellow background so that the green and red tones are particularly prominent. He omits the blooming branch that is in the original, and replaces it with a water-lily pond with high bamboo stalks, a motif he borrowed from another famous Japanese master of _ukiyo-e_ ("pictures of the floating world"). This term refers to the fleeting world of courtesans, but also stands more generally for the aesthetic orientation of Japanese art. In addition to its status as a motif typical of Far Eastern art, the crane may be a reference to prostitutes, often misunderstood in the West to be synonymous with geishas; the French word for "crane," _grue_, is also a term for a prostitute. The frog, on the other hand, is taken from a print by Utagawa Yoshiharu and simultaneously refers to the prostitute and, being white, acts as a visual echo of the water lilies (a plant that would gain great significance in French painting through Claude Monet).

More than 400 Japanese prints from the collection of Vincent and Theo van Gogh have been preserved in the Van Gogh Museum in Amsterdam. French artists bought most Japanese prints from the famous art dealer Samuel Bing. Paris was, incidentally, the European metropolis best informed about Far Eastern art, _Japonisme_ being a great success at the 1867 World Exposition in Paris. Bing also founded the magazine _Le Japon Illustré_ and organized an important exhibition of Japanese art at Agostina Segatori's café (see page 57). Van Gogh had already decorated the walls of his room in Antwerp with a few Japanese prints. In Paris, he could further indulge his passion as a great many Japanese woodcuts were on offer there at modest prices.

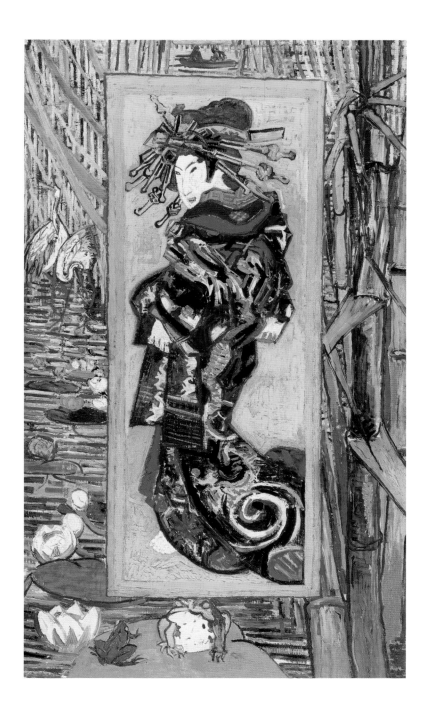

Still Life with White Grapes, Apples, Pears and Lemons, "À mon frère Théo"

Fall 1887

Oil on canvas, 48.5 x 65 cm
Van Gogh Museum, Amsterdam

"When I arrived here two years ago, it did not occur to me that we might become so close. Now that I am on my own again, I am all the more aware that my house is very empty indeed. It is not easy to replace somebody like Vincent. He has a great store of knowledge and has a clear view of the world. I am convinced that he will, if only he is given long enough on this earth, make a name for himself."

Theo wrote these lines to their mother after Vincent's departure from the apartment they had shared in Paris. The radiant colors that make up this painting are evidence of how energetic Van Gogh felt during these months: Impressionism had certainly given his painting style an injection of vivacity, even if he rejected all "isms." This still life is a "harmony in yellow." The pink, heightened with white, and the small number of dabs of blue—a very personal response to Impressionism—come together in a wonderful way. The vibrant red that marks the outlines of the pears in a few places, on the other hand, is more indebted to the decorative values of Japanese art.

Self-Portrait as an Artist

January 1888

Oil on canvas, 65.5 x 50.5 cm
Van Gogh Museum, Amsterdam

In one of the letters to Paul Gauguin Van Gogh wrote during his last months in Paris he observed: "When I left Paris, I really was in a pitiful state, quite ill and almost an alcoholic." He had the feeling that he was headed for "spiritual paralysis" because he was so exhausted by the life he lived. He explained to his sister Wilhelmina that in this portrait he had transcended the possibilities offered by the medium of photography, which he considered unable to capture the subject's inner world. He felt that, by contrast, he had managed to represent his own spiritual state "without a hint of sympathy." He chose a grayish-white wall as a background, which allowed him to control the radiance of the complementary colors, applied with decisive brushstrokes. Sadness fills the painter's gaze.

This painting has been linked to two famous self-portraits. The first is a late work by Rembrandt in the collection of the Louvre, *Self-Portrait at an Easel* (1669). There is no doubt that Van Gogh knew it, as he identified with "the toothless smile of the old lion, with a cloth on his head and the palette in his hand." The second is Paul Cézanne's *Self-Portrait with Palette* (1885–1887), from which Van Gogh borrowed the compositional framework and the ostentatiously shown palette. A comparison of this self-portrait by Van Gogh and his *Self-Portrait with Dark Felt* Hat (see page 49) executed in the spring of 1886, makes clear how far Van Gogh's painting technique had progressed in the interim. The bleak atmosphere and the thick, finely wrought application of paint characteristic of his early paintings from his period in Paris are gone. In this self-portrait, by contrast, the painting has been constructed of quickly and autonomously placed colorful lines, the brushstrokes maintaining a consistent rhythm. Everything appears as though through a filter, the details, the flesh tone, the clothing, the background—everything has been interpreted according to the painter's own perception. Even the eyes are no longer characterized by the determined, penetrating gaze seen in the painting from the spring of 1886. Now they simply express the serenity of a man who is entirely convinced of his worth as a painter.

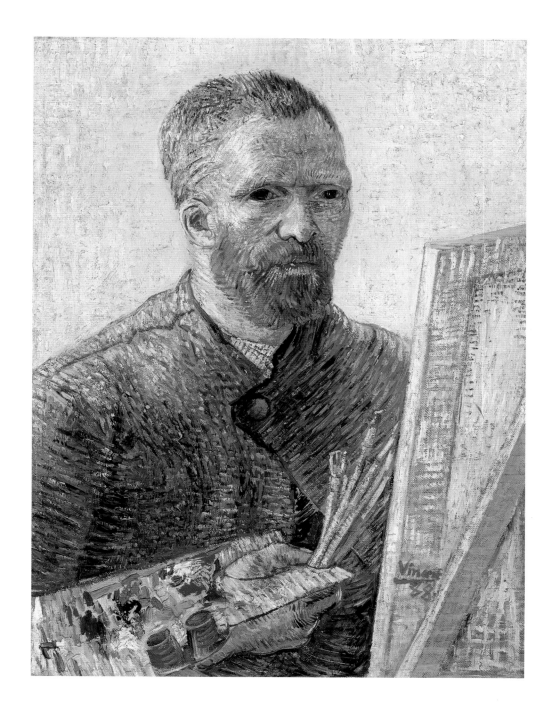

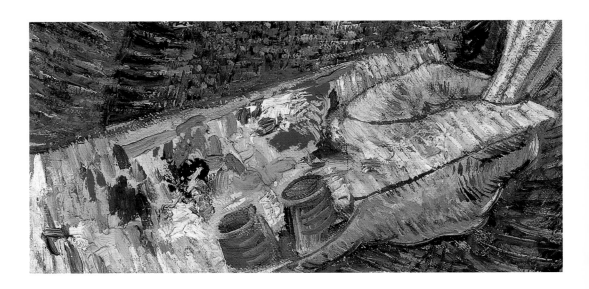

Self-Portrait as an
Artist (details)

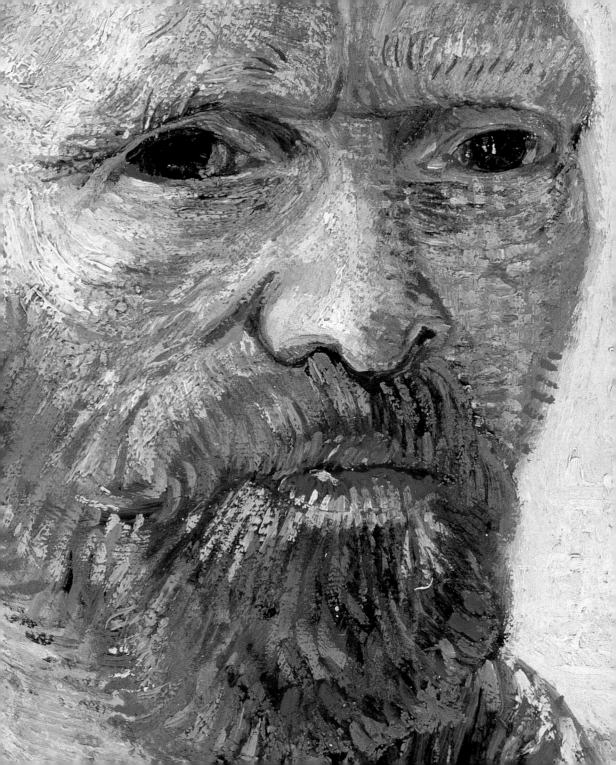

Sprig of Flowering Almond Blossom in a Glass

March 1888

Oil on canvas, 24 x 19 cm
Van Gogh Museum, Amsterdam

"It's a great shame that he does not feel the urge to earn any money, because he could certainly do so. But one just can't change people." This resigned comment by his brother Theo mirrors Van Gogh's restlessness, which now drove him to move once again. The sojourn in Paris had enriched him artistically, but had also exhausted him. In 1887 he wrote to his sister Wilhelmina, to whom he dedicated a second version of this painting: "I plan to go to the south for a while as soon as possible. There is even more color and even more sun there." On Sunday, 19 February 1888, he left Paris for Arles, a quiet little town in Provence. As soon as he had arrived at his destination, he wrote to Theo: "On my journey, I thought about you at least as much as I thought about the new countryside in front of my eyes. But I tell myself that you may come here often yourself in the future. It seems almost impossible to me that one could work in Paris without having a place of refuge where one can recuperate and regain one's calm and sense of balance. Without that, one would end up in a miserable state."

In Arles, he saw "more colors than before," and felt "able to produce something." He knew how to view nature with great respect: "The traditionalists forget entirely that Vincent sometimes reproduced nature with great accuracy and a remarkable faithfulness to the original ... His paintings are free of all that is petty, affected, designed to please, artificial or false. His work is the incarnation of the real" (Jacob-Baart de la Faille, *L'époque française de Van Gogh*, Paris 1927).

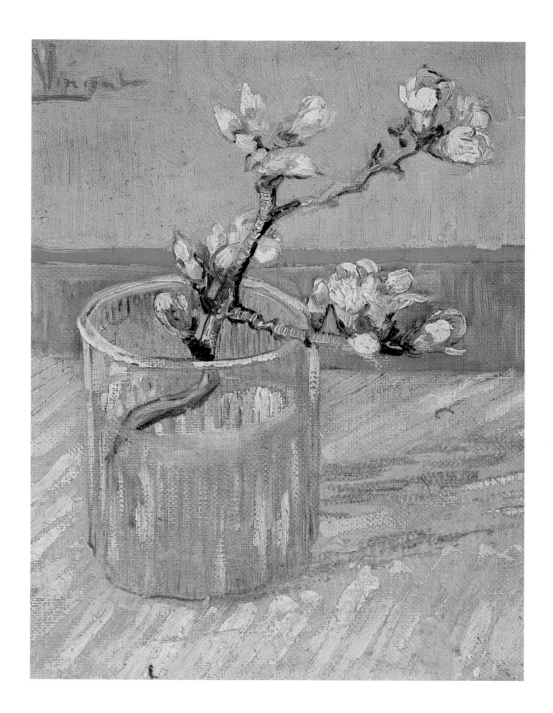

The Langlois Bridge

March 1888

Oil on canvas, 45 x 49 cm
Kröller-Müller Museum, Otterlo

"The landscape looks as beautiful as Japan to me, with its clear air and lively colors. The watercourses in the landscape are like spots of emerald and intense blue, just as they appear in the prints." With memories of his beloved Dutch landscapes on his mind, Van Gogh created a few paintings on the subject of this drawbridge over a canal outside the town of Arles in the months of March and April. The variations differ in the angle of view and the incorporation of various figures. The bridge was originally known as the Pont de Réginelle, but was later renamed for the elderly keeper of the bridge, whose surname was Langlois. It no longer exists, though a questionable replica has been constructed for tourists.

The painting limits itself to a small number of compact forms, and one can clearly see what Van Gogh learnt from Japanese prints. Several women are washing laundry on the river-bank. The grass is the delicate green of spring and the milky white of the sky is reflected in the water. In a letter dated March 1888, he wrote: "But if one intensifies all the colors, one returns to calm and harmony. It is similar to what happens with Wagner's music: it is played with a large orchestra, but that does not make it any less intimate."

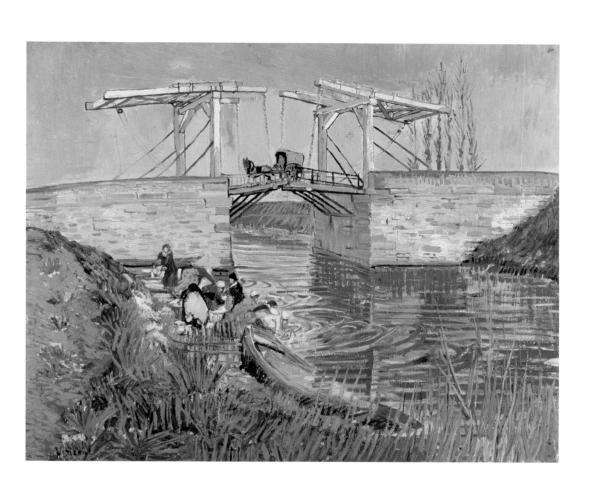

The Pink Orchard

March–April 1888

Oil on canvas, 64.5 x 80.5 cm
Van Gogh Museum, Amsterdam

Living far away from the hustle and bustle of city life once again, in Arles Van Gogh immediately went out into nature. After all, art was, to him, "man plus nature." It is probably not particularly important to understand why he chose to move to Provence of all places, though three people whom he admired very much may have strengthened his connection to this light-filled region of France: Adolphe Monticelli, Émile Zola, and Paul Cézanne. In the spring, he felt quite overwhelmed by the awakening of nature. Here he found the "Japan" of his dreams, of his copies after Japanese art from the previous year. When he came to paint the flowering fruit trees, he no longer needed to take his cues from Japanese prints, as he had, for example, with the wonderful sprig of almond in a glass (see page 77). By the time the blossoming of the fruit trees had come to an end, fourteen paintings had been created. What caused Van Gogh to paint the same motif again and again? It must have been the dramatic quality of the blossoming flowers, the play of the light on the delicate petals—the Impressionist model was still vivid—and, perhaps, the hope that such a motif might appeal to art lovers. Artists such as Jean-François Millet and Charles-François Daubigny had interpreted the subject of the flowering orchard before him. Van Gogh gives the subject his very own quality of timeless beauty. He suggested that Theo might keep the two paintings of an orchard and the one of a peach tree, to form in effect a triptych, rather than selling them straight away, as their "value will increase to 500 francs."

The perspectival composition of the painting is quite simple and limited to the essentials: the spatial context is only hinted at in order to provide a setting for the central subject of the painting—the flowering tree in all its glory. The light and fragrant blossoms that are beginning to open have been dabbed onto the canvas with a few brushstrokes in white and yellow. They sprout on twigs that are represented by fine blue lines, while the tree trunks are painted in violet-blue and dark-green tones. They are gently contrasted with the grass, which is primarily painted in green and yellow. Little patches of bare soil here and there indicate that the grass is still growing.

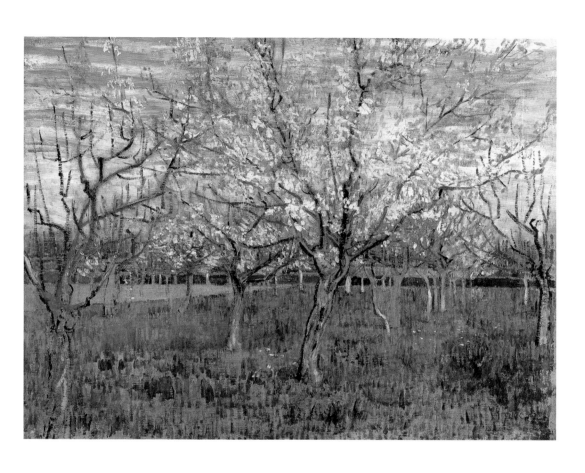

Fishing Boats on the Beach at Saintes-Maries-de-la-Mer

June 1888

Oil on canvas, 65 x 81.5 cm
Van Gogh Museum, Amsterdam

During his time in The Hague, Van Gogh had dreamed that "sand, sea and the sky are some-thing that I very much hope to express one day." He was now capable of producing paintings of the highest technical standards and set himself a new challenge: to create fifty paintings to be presented to the public in an exhibition. And so he decided to go to a small fishing village in the Camargue in southern France that was famous for being a place of pilgrimage for the Roma, who gathered there in May every year to pray to their patron saint, Sarah. The painting is based on a reed-pen drawing he had made in front of the subject, to which he added written notes on the colors to be used. While the sea is the main subject of the other paintings in the series, here the focus is on the boats, the fishermen's tools of their trade. Van Gogh described the scene to his friend Émile Bernard: "...little green, red, blue boats, so pretty in shape and color that one cannot help but think of flowers." The composi-tional structure of this painting is of interest. The name of one of the boats appears on the central vertical axis: "Amitié" (friendship). The shapes of the fishing boats are formed by generous areas of color reminiscent of the stylizations of Japanese art. The painting is an example of the successful balance between naturalism and symbolism. The artist loved the vibrant colors of the Mediterranean world. He remembered the small number of days he had spent in the Camargue region in southern France with great fondness as they not only made him feel at ease but also renewed his strength.

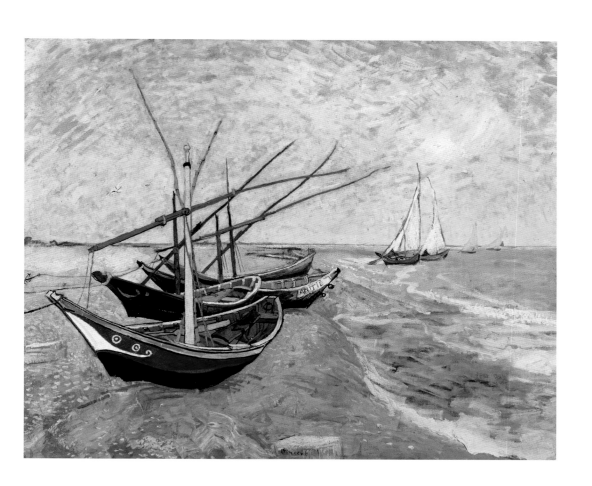

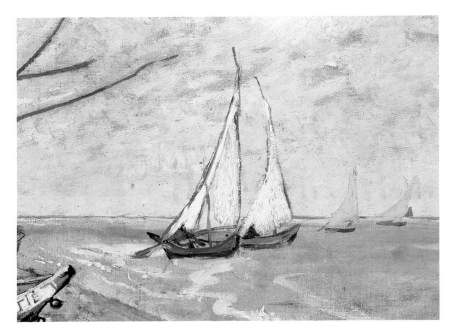

Fishing Boats on the Beach at Saintes-Maries-de-la-Mer (details)

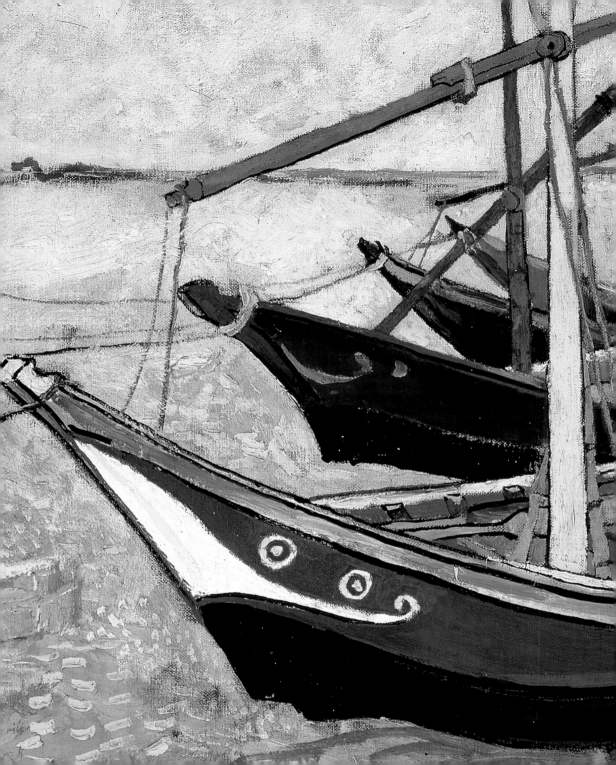

The Harvest at La Crau

June 1888

Oil on canvas, 73 x 92 cm
Van Gogh Museum, Amsterdam

Between 12 and 20 June 1888, Van Gogh dedicated himself to another series of paintings
that, developed much further than his preceding series, achieved breathtaking artistic
quality—the series on cornfields. He spared no effort with this example, painting in the
scorching sun and taking only one break; then a terrible thunderstorm destroyed the entire
crop. He wrote to his brother Theo that this painting was as much of a success in his eyes
as *The White Orchard*, but that it felt more solid and had more style. As a man of the north,
he knew how to paint the subdued colors of his native environment. Now, however, he was
inebriated by the bright sunlight and experienced "burning nature." He painted the ears of
corn in yellow and red brushstrokes in the foreground. The eye caresses every object all the
way to Montmajour Abbey and the mountain range of the Alpilles in the background. In his
paintings of orchards, Van Gogh was able to capture the tenderness of spring. Here, he
captured the fullness of summer, the "contrast of the blue tones against the saturated
orange, the golden bronze of the grain." He was certainly aware of his own skill, though
deep down he remained modest. In any case, he mentioned this painting in three letters to
his brother Theo: "This ... painting is superior to all the others," he wrote. All of the motifs
he associated with work and with farm life are to be found in this painting: the cart, the
simple house, the garden, the harvested field. The scene is framed by the mountain range,
which appears in the background in blue-green tones with a few splashes of white.

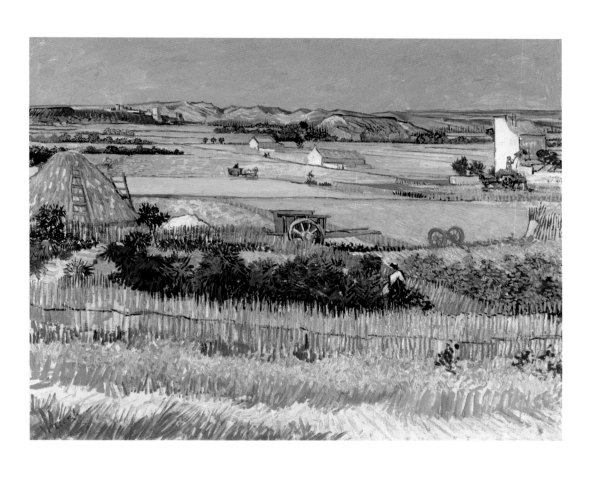

La Crau from Montmajour

July 1888

Pencil, goose quill and reed pen with brown and black ink on Whatman paper, 49 x 61 cm
Van Gogh Museum, Amsterdam

This drawing is one of a large number of sketches on the subject of the "harvest land-scape." Van Gogh had tried his hand at reed-pen drawings in Saintes-Maries-de-la-Mer, developing a very free style, and this landscape clearly shows to what degree he had mastered the technique by this point. Artistically, too, the drawing is of the highest quality. Montmajour Abbey, the "ruin on the hill," had fascinated him since his arrival in Provence, and he used it as a linear accent far away in the background of a number of works. He later went there himself, documenting in his letters to his brother the various stages of the ap-proach to the abbey, and enumerating all of the studies he made of the rock and the vegeta-tion he passed on his way. This view from the abbey captures "the flat landscape, seen from above, with its vineyards and stubble fields," about which he said: "I prefer it to the sea be-cause, while it does not appear less infinite, we view it as inhabitable." There is no indication of the time of day or weather conditions under which this drawing was made. Even so, it is easy to imagine that Van Gogh could have made this sketch into another wonderful painting if the wind had not prevented him from finding a stable position for his easel. The rocks in the foreground are recreated with confidently placed dots and bundles of short lines, while the trees in the middle distance are executed with curved, overlapping lines. He created an impression of the fields using dots, too, whereas he used black and brown lines for the representation of the vineyards.

The Yellow House

September 1888

Oil on canvas, 72 x 91. 5 cm
Van Gogh Museum, Amsterdam

The artist Paul Signac remained loyal to Van Gogh throughout the latter's short life. He wrote about a visit to Arles: "I went into his living quarters at the Place Lamartine, and saw wonderful paintings there, all of them masterpieces: *Les Alyscamps*, *The Night Café*, *La Berceuse*, *The Lock*, *View of Saintes-Maries*, *Starry Night* and others. Just imagine the spectacle of the whitewashed walls from which his colors shone in all their freshness." The living quarters mentioned were in the famous Yellow House. The painter had always dreamed of a house such as this, in which he could work in peace and provide accommodation for friends who came to visit.

The little house, shown in the glaring sun, seems to glow from within. Van Gogh had rented it in early May, and described it in a letter to his brother Theo. Here he wanted to realize his long-standing ambition to establish a community of artists. He had always believed in working in groups, which he felt provided stimulation and support, and he imagined a community modeled on the fraternities of Dutch painters of the eighteenth century. He soon came up with a suitable name: Atelier du Midi. To whom should he turn? Paul Gauguin, one of the spiritual fathers of Synthetism, was the first name that came to mind. He had met Gauguin in Paris and considered him to be "brave and authentic."

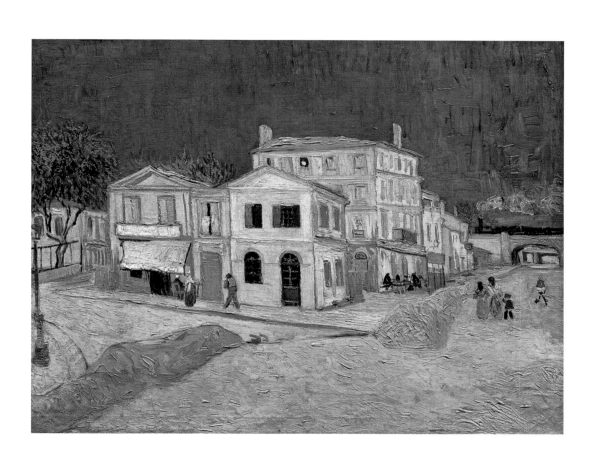

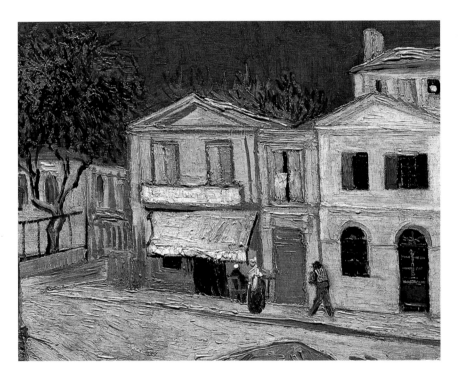

The Yellow House
(details)

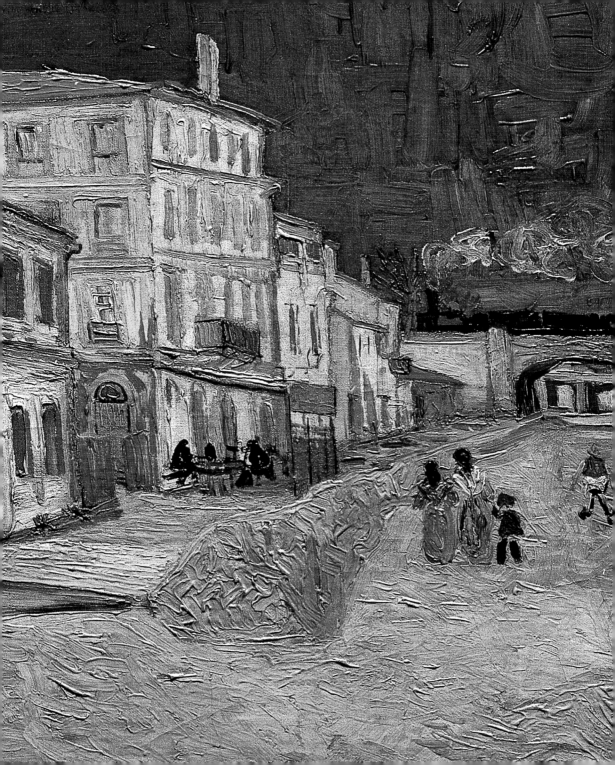

Portrait of Eugène Boch

September 1888

Oil on canvas, 60 x 45 cm
Paris, Musée d'Orsay

Eugène Boch, the son of a Belgian industrial magnate, moved to Paris from the coal-mining region of Borinage in 1879. "This Boch has a head that is slightly reminiscent of that of a Flemish aristocrat from the time of William I. I would not be surprised if it turned out well." The portrait is characterized by a close likeness, as becomes clear when it is juxtaposed with a photograph of the sitter. But Van Gogh simultaneously gave him a symbolic dimension. A starry night sky serves as the background, and the top of the young man's head is framed by an ocher-colored outline that suggests a halo. Vincent explained his artistic intentions to his brother Theo, writing that "I'd like to paint men or women with that something of the eternal, of which the halo used to be the symbol, and which we try to achieve through the radiance itself, through the vibrancy of our colors."

The spectrum of tones used here is considerably reduced and harmonious: ocher, light green, blue. In 1950 the French critic Jean Leymarie wrote of Van Gogh's great portraits: "The Impressionist view questioned the continuation of the genre of the portrait; the human face, like the sky and the sea, was subordinated to an obscuring play of colors; to the Impressionist eye, it increasingly became a purely superficial phenomenon that had little, or even no, life left in it at all ... Van Gogh's portraits were in this context an unexpected revelation. And this is all the more astounding when one considers that they were created at a time when his drawing and his colors became increasingly free and abstract and independent of nature."

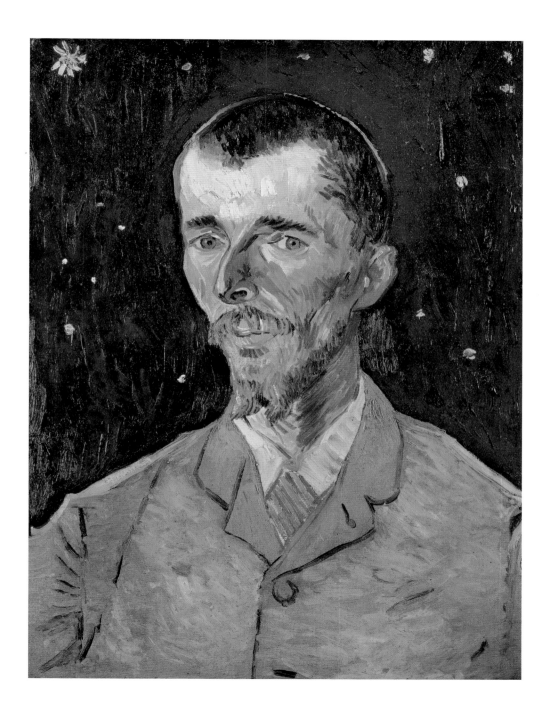

The Night Café

September 1888

Oil on canvas, 72.4 x 92.1 cm
Yale University Art Gallery, New Haven

This painting, to which the artist accorded equal status with *The Potato Eaters* (see page 39) was created in the course of three long nights. Every object, big and small, is shown heavily distorted, as though dissolved by the harsh light. To Van Gogh's great delight, the painting proved to be a sort of illusion, a dream picture dominated by a feeling of fear and emptiness. The big wall clock arrests time for the last drunkards who have fallen asleep, the silent, tired denizens of a night that has been captured with brilliant originality. He wrote to Theo: "In my painting of the night café I've tried to express the idea that the café is a place where you can ruin yourself, go mad, commit crimes. Anyway, I tried with contrasts of delicate pink and blood-red and wine-red. Soft Louis XV and Veronese green contrasting with yellow greens and hard blue greens. All of that in an ambience of a hellish furnace, in pale sulfur. To express something of the power of the dark corners of a tavern."

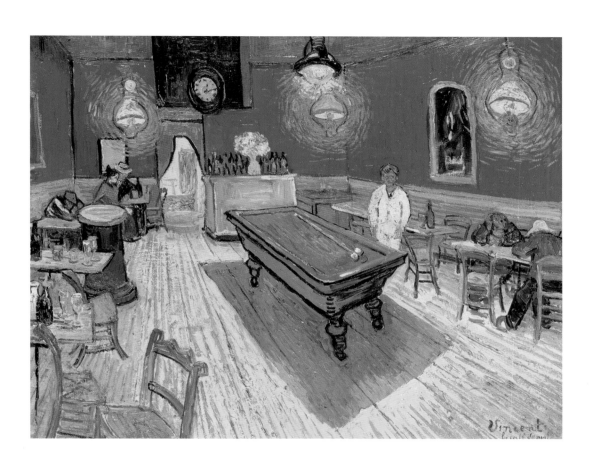

Café Terrace at Night

September 1888

Oil on canvas, 81 x 65.5 cm
Kröller-Müller Museum, Otterlo

"Small figures sit on the terrace ... An enormous yellow lantern lights up the terrace, the front of the building, the pavement, and even projects its light onto the cobblestones, which are bathed in pink-violet tones. The façades of the buildings on the street that extends beneath the starry sky are dark blue or violet, a green tree in front of them." The motif here is less dramatic than in *The Night Café* and is more reminiscent of the cheerful depictions of Montmartre or the ramparts on the outskirts of Paris. The construction of the painting is perspectively correct, with the vanishing point at the center, near the waiter in white. The passers-by on the square, caught in the warm and cheerful ambiance of the café, observe each other attentively. The paths of the woman with the bonnet and shawl and of the man whose hands are in his pockets cross, and their eyes, too, will surely meet. The little café tables gleam as brightly, enticing those who walk past, regulars and strangers alike. They look like little summer moons, one next to the other, reflecting the nocturnal lights. This time, the stars appear like small flowers in the sky; Henri Matisse would later say that flowers were like stars on earth. Color sings; here it is a medium used to achieve the absolute. The seeds of the most daring coloristic adventures of modern art, from the Fauves to the Expressionists and beyond, are to be found in this groundbreaking colorism.

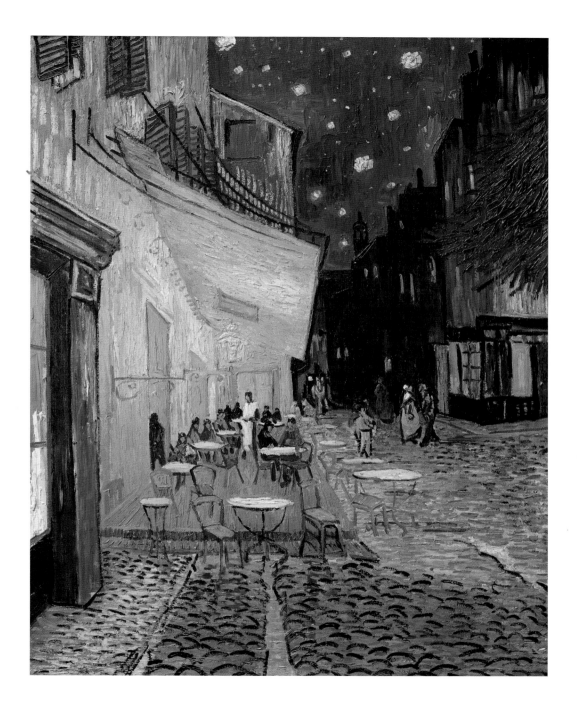

The Bedroom

October 1888

Oil on canvas, 72 x 90.5 cm
Van Gogh Museum, Amsterdam

Van Gogh wrote to Paul Gauguin that he had made a painting of his "bedroom, with furniture of untreated wood, as you know. Well, it gave me a lot of pleasure to paint this interior with nothing in it, with a simplicity à la Seurat: flat colors, but applied crudely, very thick ... You see, I wanted to express a complete calm in these very different tones, there is no white in it, except for a small accent in the mirror in the black frame." In this case, too, Van Gogh was entirely aware of the fact that he had created a masterpiece. It is a depiction of his own life, a mirror of his inner world, but simultaneously a painting that is subtly balanced in terms of composition and coloring.

He understood this subject as a metaphor for his personal life; in the early stage of its development, he even considered adding a naked woman on the bed or a cradle. He also thought about surrounding the liveliness of the coloristic whole with a white frame. Later, while he was in the psychiatric clinic of Saint Rémy, he painted two copies of this work, which had become for him a symbol of a life irretrievably lost. He has placed everyday objects on the table; they are humble, but they are his own, and that is enough; for him all the objects in the room had a soul of their own. This painting was not an exercise in perspective, but the—successful—attempt to create an intense image of a life, an image in which each element is imbued with emotional significance. The room is small and bare. The white furniture has been painted yellow, and on the walls there are a few of his own paintings, including a self-portrait.

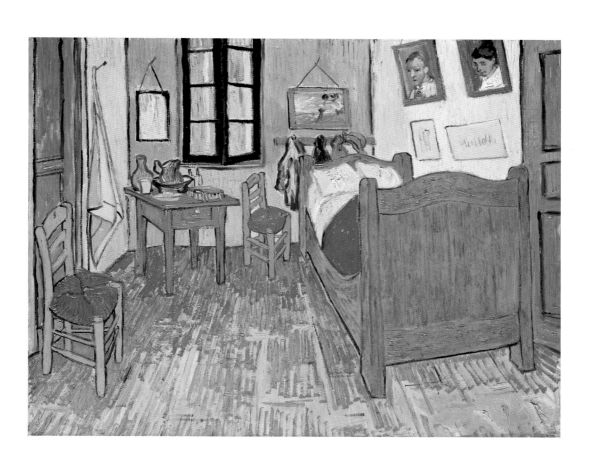

Falling Autumn Leaves (Les Alyscamps)

October–November 1888

Oil on canvas, 72 x 91 cm
Private collection

In the enchanting little town of Arles in Provence there is a place that has a very particular charm: a pagan necropolis in which Jesus is said to have appeared on the day that the first bishop of Arles consecrated the burial ground in the name of the new religion. For centuries the inhabitants of the region—first the Celts and later the Romans—had interred their dead in this place because they believed that an easier journey led from there to the Elysian Fields. For this reason, the graveyard is called Les Alyscamps (Provençal for Champs-Elysées, or Elysian Fields). It continued to be in use throughout the entire Middle Ages. Van Gogh painted here with Paul Gauguin.

In this painting, too, he took inspiration from Eastern art: the unusual perspective of an elevated, diagonal point of view is derived from Japanese prints. Similarly, line is also of particular importance, though it interested him not so much as an independent form of expression but rather as a medium for bounding areas of color, thus giving them greater intensity. Thus the outlines of the trees, which create a strong vertical rhythm, immediately draw our attention. In this picture we perceive an unreal, metaphysical pictorial space, as though Van Gogh had wanted to emphasize the value of the other-worldly.

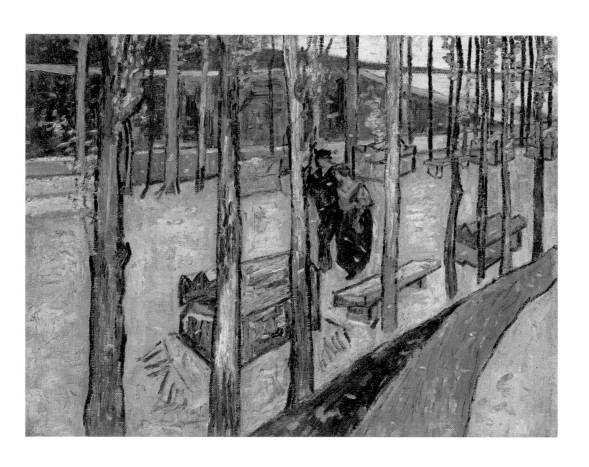

The Sower

November 1888

Oil on canvas, 32 x 40 cm
Van Gogh Museum, Amsterdam

This painting is the last of a series dedicated to people working in the fields. When compared to the works executed in the summer, the differences in content and painting style are striking. The sun depicted here does not emit warmth, and though it is positioned just above the horizon it looks like a hallucination, or the symbol of an energy that is being extinguished (the inverse of the "sun myth" the critic Albert Aurier mentions in his article of 1890, _Les Isolés: Vincent van Gogh_).

The painting is a highly successful combination of bold composition and strong color harmonies. It shows that Van Gogh's interest in Impressionism led not to a purely mechanical imitation of the painting technique, but to a very personal interpretation in which he simultaneously made reference once again to the graphic stylization of Japanese art and also anticipated the pictorial language of Symbolism. He had reached a point at which he was essentially giving an account of himself. Paul Gauguin's presence did not lead to the stimulation he had hoped for, but instead to an almost destructive clash of personalities. Van Gogh had gone to Provence to find himself, but without success. The "illness," as he called it, progressed rapidly and his hallucinations, followed by periods of total exhaustion, became increasingly frequent. He was sometimes angry because he was not able to make himself "understood by Gauguin," causing a state of almost unbearable tension. Even before his artist-friend arrived, he wrote: "I feel compelled to work until I am spiritually crushed and physically exhausted, simply because I have no other way of covering the expenses." A little later: "My paintings are worthless, but they exact a great price from me, sometimes costing me my blood and my brain." This was not a sustainable situation. After the tragic episode in December, when he attacked Gauguin, then cut off part of his left ear and gave it to a prostitute as a "gift," the women in the brothel alerted the police and called neighbors to help. The "virtuous locals" surrounded his house: they wanted peace and quiet to return, and so Van Gogh was sent to the asylum.

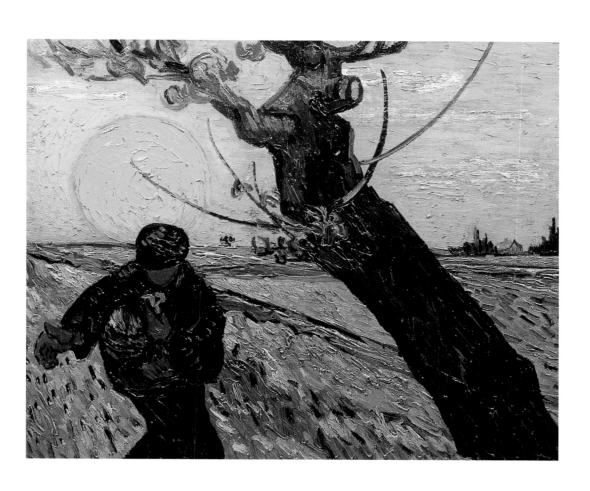

Gauguin's Chair

December 1888

Oil on canvas, 90.5 x 72.5 cm
Van Gogh Museum, Amsterdam

"A few days before we parted, when illness forced me to enter an asylum, I tried to paint 'his [Gauguin's] empty place.' It is a study of his armchair of dark, red-brown wood, the seat of greenish straw, and in the absent person's place a lighted candlestick and some modern novels." This description of the painting illustrated here is to be found in a letter to the art critic Albert Aurier, written on 9/10 February 1890. Here, Van Gogh summarizes in a few simple words the sad events that took place on 23 December of the previous year, and tells of his psychological and physical state of health. Van Gogh had always been interested in the chair as a motif, and chairs are among the subjects be sketched repeatedly in 1881 and 1882. In *The Graphic*, an English journal, he had come across an engraving by Luke Fildes depicting the empty chair of Charles Dickens, an image created in 1870 to mark the death of the writer. Van Gogh was never to forget the image. In this painting, Van Gogh tried to create a "night effect." It is to be understood as a pendent to *Van Gogh's Chair* (1888), a slightly larger oil painting that is also in the Van Gogh Museum in Amsterdam. There are visible differences despite the similar subject matter: the representation of his fellow artist's chair is dominated by dark, cold tones, whereas his own features a preponderance of light, bright, warm colors. Gauguin had fled the Yellow House in horror after Van Gogh, in a state of great agitation, had attacked him with a razor. He left Arles the following day.

Self-Portrait with Bandaged Ear

January 1889

Oil on canvas, 51 x 45 cm
Private collection

This painting is the sad document of the heartbreaking story of Vincent van Gogh's friendship with Paul Gauguin. It is a story characterized by affection, hope and exuberance, anger and disappointment … a story that inevitably came to a tragic end. There is another, slightly different version of the painting, in which Van Gogh appears without a pipe, in front of an olive-green background showing a Japanese print. This second self-portrait expresses a different emotional tenor: Van Gogh actually appears less unhappy.

His gaze in the self-portrait illustrated here is unforgettable: the red background appears to be reflected in the bloodshot eyes, a reference to the blood that is not shown here but is instead indirectly evoked. The composition is quite conventional: a triangle rising from the two lower corners. And yet the application of paint shows a dynamic energy that is only just contained by the black outlines. The muted green of the coat with the threadbare lapel and the asymmetry of the slumped, slightly hunched shoulders underline the vacant expression of the subject. He appears to be completely shut off from the outside world because he is wounded—and not just physically—and he presents himself without a hint of self-justification or romantic self-stylization. Gauguin had, however, described him as a romantic in a letter to Émile Bernard, for Van Gogh loved "Daumier, Daubigny, Ziem and the great Rousseau, none of whom I can stand."

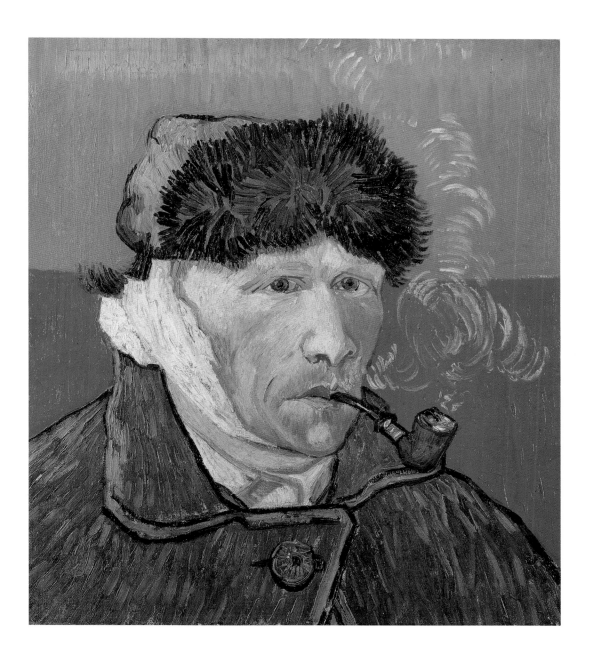

Starry Night with Cypresses

January 1889

Oil on canvas, 73.7 x 92.1 cm
Museum of Modern Art, New York

In this painting, which is certainly among Van Gogh's most famous works, the star-studded sky becomes a dizzying swirl and the landscape, painted from nature, a vivid demonstration of the painter's compositional and expressive brilliance. One could view this painting as an extreme attempt to go beyond the simple pictorial representation of nature towards a creation based on inner realities that is at once monumental and concrete. Both the verticality of the imposing cypress tree and church tower in the background, and the diagonals of the rolling hills and surreal swirls in the starry sky, characterize the basic structure of the complex composition. Here Van Gogh has designed an imaginary journey in which the landscape becomes a fantastical perception, a transcendental experience, a joyful distortion of the senses, a poetic adventure. His thought, and consequently his work as a painter, never developed into the explicit Symbolism of his friends Paul Gauguin and Émile Bernard. He always remained dedicated to visible nature, even if he distorted it. In this painting, the viewer has no choice but to be drawn into the painter's mental nocturnal maelstrom, into the cosmic energy that appears to radiate from the night sky over Arles. The circling brushstrokes are certainly among the most powerful and most famous creations of modern painting.

La Berceuse (Augustine Roulin)

January 1889

Oil on canvas, 92 x 73 cm
Kröller-Müller Museum, Otterlo

This painting, of which there are five versions by Van Gogh, each with small differences, shows Augustine Roulin, the wife of the postmaster of Arles. She is shown in the pose of a matron, in front of a background of floral arabesques that can be traced back to Japanese models. The harmony of the colors and the clearly painted black contours position the figure in a realm beyond time and space. Madame Roulin appears thoroughly real in the physicality of her heavy body, and yet Van Gogh has carefully idealized her, making her into a universal type: the "mother at the cradle." In a letter to Theo dated 28 January 1889, he relates how he had discussed with Gauguin the "melancholy isolation" of Icelandic fishermen, and how "following these intimate conversations, the idea came to me to paint such a picture that sailors, at once children and martyrs, seeing it in the cabin of a boat of Icelandic fishermen, would experience a feeling of being rocked, reminding them of their own lullabies." A few days before, in a letter to his friend Arnold Koning, he had described the painting in the following terms: "It's a woman dressed in green (bust olive green and the skirt pale Veronese green). Her hair is entirely orange and in plaits. The complexion worked up in chrome yellow, with a few broken tones, of course, in order to model. The hands that hold the cradle cord ditto ditto. The background is vermilion at the bottom (simply representing a tiled floor or brick floor). The wall is covered with wallpaper, obviously calculated by me in connection with the rest of the colors. This wallpaper is blue-green with pink dahlias and dotted with orange and with ultramarine. ... Whether I've actually sung a lullaby with color I leave to the critics ... to decide."

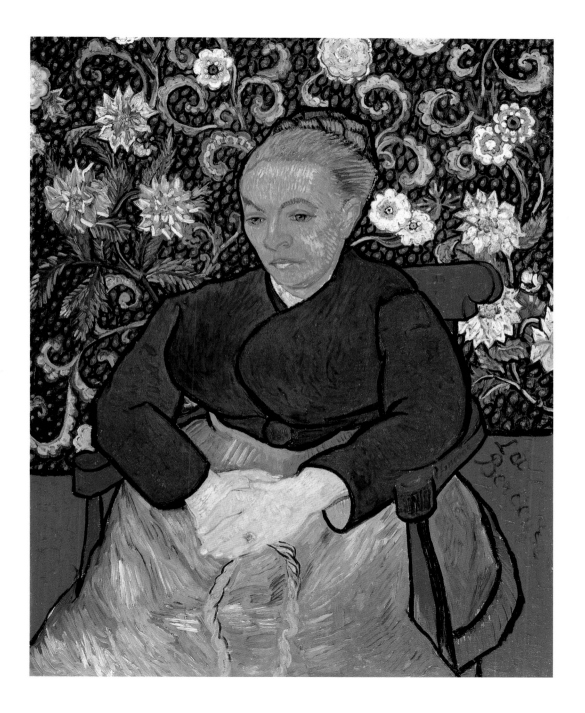

Cypresses with Two Female Figures

June 1889

Oil on canvas, 92 x 73 cm
Kröller-Müller Museum, Otterlo

"The cypresses are always on my mind ... In terms of line and proportion, they are as beautiful as an Egyptian obelisk. And the green is such a delicate tone. It's the black blotch in a sunlit landscape, but it is one of the most interesting black tones, though I can't imagine one that would be more difficult to get right. One has to see the cypresses here against the blue, or rather *in* the blue." In Van Gogh's opinion, after the olive, the cypress is the tree most characteristic of Provence. In the perceptive review that Albert Aurier had dedicated to him in the January 1890 edition of the periodical *Mercure de France*, the critic wrote enthusiastically of "cypresses that stretch their eerie silhouettes towards the sky, like black flames." As a gesture of thanks, Van Gogh sent him a painting with this very subject.

Traditionally, the cypress is associated with death; but as the tree is also a strong tree, and thus can be seen as a metaphor for vigorous life, it is tempting to identify it with the painter himself. Describing his visit to Paris to see Theo and his little nephew, his sister-in-law Johanna later noted: "I had expected to see a sick man, but there stood before me a robust man with broad shoulders and a healthy complexion, with a cheerful expression in his eyes and a sense of purpose in his appearance." But this sense of well-being would not last for long.

In this painting, Van Gogh achieved a wonderful harmony between the various shades of green, and used black in order to convey an especially dark shadow. The thick, curved brushstrokes used to convey the movement in the trees and undergrowth are continued in the light blues and white of the sky and clouds. The whole scene seems animated by the same energy.

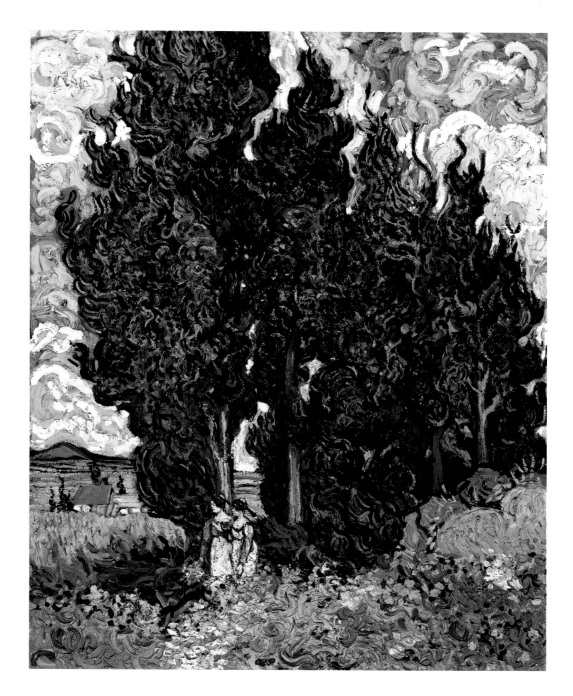

Cypresses with Two
Female Figures
(details)

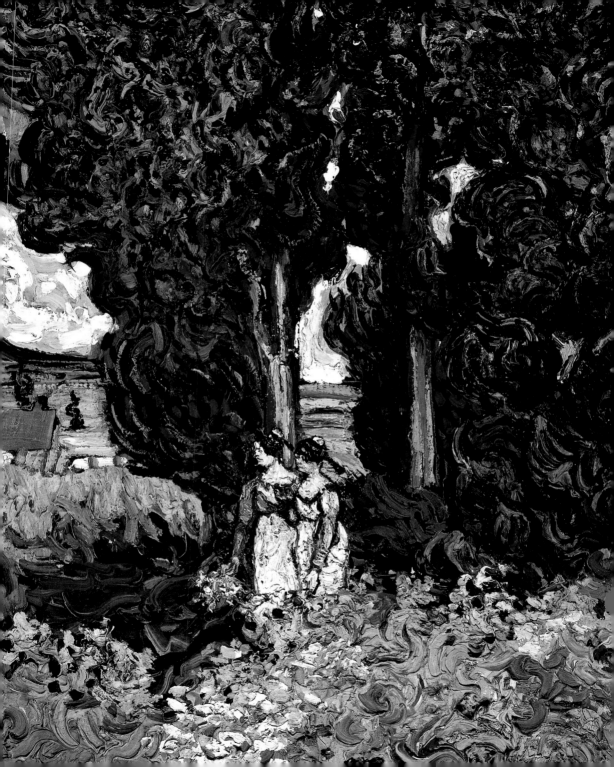

Wheatfield with a Reaper

September 1889

Oil on canvas, 73 x 92 cm
Van Gogh Museum, Amsterdam

In a letter to Theo dating from early September 1889, Van Gogh described this painting as follows: "A reaper, the study is all yellow, terribly thickly impasto, but the subject was beautiful and simple. I then saw in this reaper—a vague figure struggling like a devil in the full heat of the day to reach the end of his toil—I then saw the image of death in it, in this sense that humanity would be the wheat being reaped. So if you like it's the opposite of that Sower I tried before. But in this death nothing sad, it takes place in broad daylight with a sun that floods everything with a light of fine gold." In their clear-sightedness, which here assumes a prophetic character, Van Gogh's comments provide an insight both into the work itself (which was intended for his sister Wilhelmina and their mother) and also into his personality and feelings. He had already depicted the subject of the reaper in July, but had put the painting to one side after a sudden crisis; he later resumed work but was apparently not satisfied with the result and painted a second version. In that respect Van Gogh was a perfectionist, for he was determined to record *his* view of reality, and if he encountered obstacles he felt himself obliged to overcome them at all costs. His art is never naturalistic in the ordinary sense: "Because instead of reproducing exactly what I can see, I use color in a more individualistic manner in order to express myself emphatically."

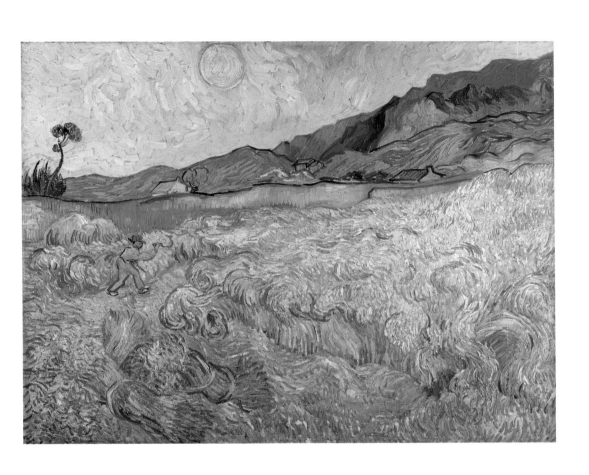

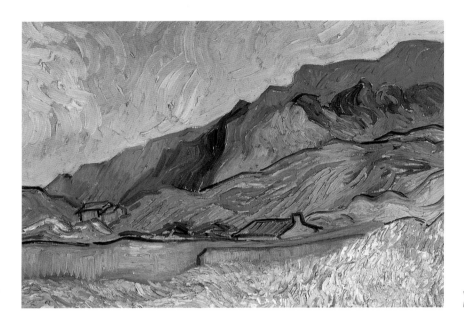

Wheatfield with a Reaper (details)

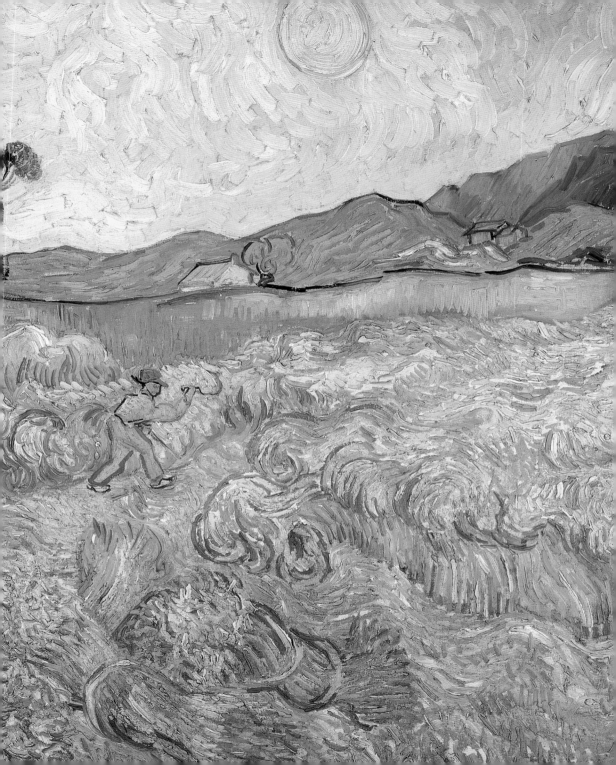

Portrait of a Patient in Saint-Paul

October 1889

Oil on canvas, 32.5 x 23.5 cm
Van Gogh Museum, Amsterdam

Van Gogh had not succeeded in settling in Saint-Rémy, but he went to great lengths to make
the conditions of his stay there as bearable as possible: "Work is a thousand times better for
me than anything else, and if I were only able to throw myself into it with all my strength,
I think it would be the cure for everything." He loved painting certain corners of the garden
in Saint-Paul's asylum, and also executed a large number of portraits of himself and the
people around him, the attendants and the patients. The portrait of a man shown here is one
of the most successful works from this period. Although Van Gogh normally painted men
and women who enter into a dialogue with the viewer, here the sick man's gaze is focused on
the far distance. Van Gogh had a high opinion of Théodore Géricault, the first artist of French
Romanticism. This can clearly be seen in this portrait, in which he pays respect to the great
painter, for he had studied Géricault's series of portraits of mentally ill men and women,
created in 1820, in great depth. This series of paintings by Géricault (which remained unfin-
ished) was a pioneering achievement in modern art, and important above all in its attempt at
a precise, unprejudiced observation of the insane. In his portrait, Van Gogh dispenses with a
flattering representation of external appearances. There is no false pity, only uncompromis-
ing honesty. What is this man looking at in his suffering? The question is superfluous. Per-
haps he does not even know himself. It is the look of a man whose illness has made him
defenseless, dull, absent. What has happened to the firm mouth of Gordina, his model in the
peasant pictures from Nuenen (for example in *Head of a Peasant Woman with White Hood*,
1885, Kröller-Müller Museum, Otterlo)? This mouth would perhaps even has difficulty
uttering a few words. What is truly masterly is the treatment of the jacket. Sea-green, black
and brown are applied in long brushstrokes that convincingly reproduce the impression of
the fabric, marked by traces of the neglect of a man who no longer cares about his own
appearance. At the same time the colors develop a value of their own, and the emphasis on
line still faintly recalls the art of Japan, while here the summary depiction already points
forward to Expressionism.

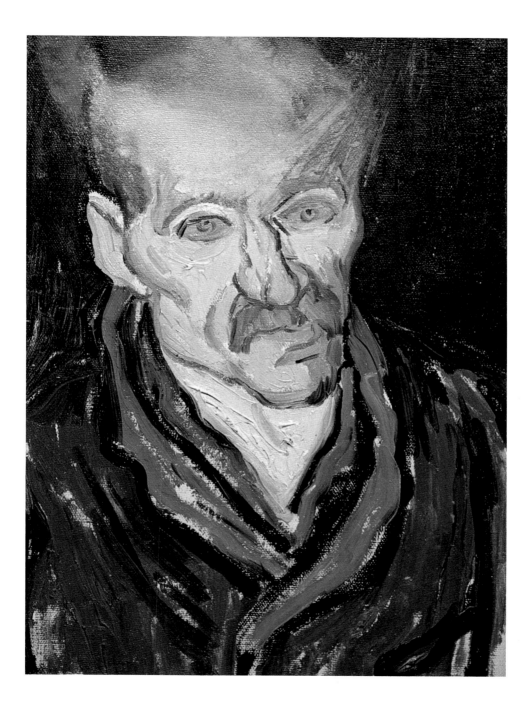

Almond Blossom

February 1890

Oil on canvas, 73.5 x 92 cm
Van Gogh Museum, Amsterdam

To mark the birth of the son of Theo and Johanna, who was also to be named Vincent, Van Gogh painted "a large sky-blue painting ... with blossoming twigs." The picture was hung above the bed of the new parents. Theo wrote to his brother that the baby looked at it "fascinated." In this work Van Gogh is probably still referring to Japanese prints. It was to be the first work in a series, but he was unable to continue because, shortly after he had completed the picture shown here, he suffered another crisis, and when he had recovered the blossom season was already over. "I just don't have any luck," he commented.

On the other hand, the month of January had provided him with an opportunity to which he responded in an unexpected way. The art critic Albert Aurier, who was in contact with Émile Bernard, published an enthusiastic article about his art in the *Mercure de France*, the preferred journal of the Symbolists. This essay, *Les Isolés: Vincent van Gogh*, was the first item in the Van Gogh bibliography, which has now reached incalculable proportions. Van Gogh wrote in alarm to his mother that "success is the worst thing that can happen to an artist." Indeed, Van Gogh was represented at the seventh exhibition of the Belgian art group Les Vingt (The Twenty) with six paintings and people were, finally, talking about him—both favorably and unfavorably. Henri de Toulouse-Lautrec even went so far as to challenge to a duel a colleague who had made a derogatory remark about his friend's works. One of these paintings, *Red Vineyard* (painted in Arles in 1888, now in the Pushkin Museum in Moscow), was purchased for 400 francs by the painter Anne Boch, the sister of the artist Eugène Boch, whose portrait Van Gogh had painted in Arles (see page 97).

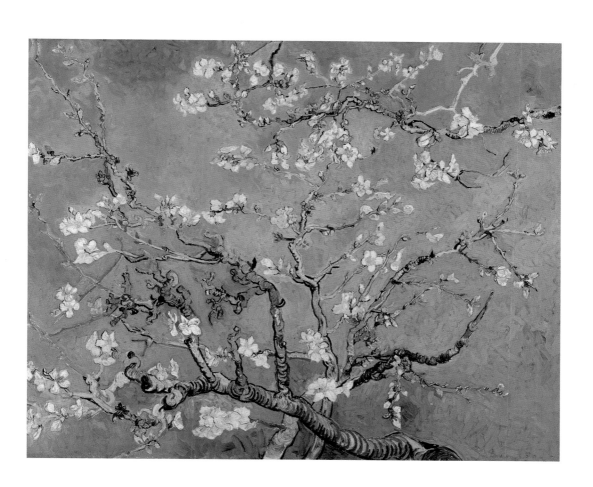

View of Auvers

1890

Oil on canvas, 50 x 52 cm
Van Gogh Museum, Amsterdam

When he was in Auvers, Van Gogh found it physically exhausting even to hold a paintbrush, and yet he painted over seventy pictures in just over two months. His mental state was that of a man who realizes that he has reached a decisive point in his personal as well as professional life. We can indeed see that his style during this period was in a transitional stage, a phase of clarification. In this respect it is interesting that Dr. Gachet, Van Gogh's doctor in Auvers, was an art collector and that Van Gogh may well have studied artworks in the doctor's house. These included works by Paul Cézanne, who played a central role in the development of painting during this period, especially landscape painting. The severe beauty of nature in this corner of the Île-de-France, the sincere esteem Dr. Gachet demonstrated towards him during their meetings, and the slow recovery he made during these weeks—all this clearly created the preconditions for a phase of carefree creativity in which Van Gogh scarcely needed to think of the black clouds on the horizon. The picture conveys the impression of the relaxed nature of the place, the last period of tranquility he was to enjoy. He invited his brother to leave Paris, "even if it is only for a month," in order to live in a "tranquility as in a Puvis de Chavannes." What is also unusual is the application of the paint, which looks as if Van Gogh wanted to create the impression of a silky green film, which consists only of colors that blend with the clayey tones. The section of the painting devoted to the sky seems unfinished.
"If I work on painting them [the houses] seriously, perhaps I will succeed in earning the costs of my stay here," he wrote to Theo. And in a letter to Émile Bernard he expressed his admiration for these peasant's huts, "with their roofs of moss and straw and with their smoking chimneys." Paul Cézanne had also painted this corner of countryside a few years previously. Where Van Gogh developed a decorative arabesque of harmonizing shades of green in order to suggest the shapes of the bushes, Cézanne's compact, diagonal brushstrokes are consciously non-decorative as they develop the "plastic volume" of the same forms.

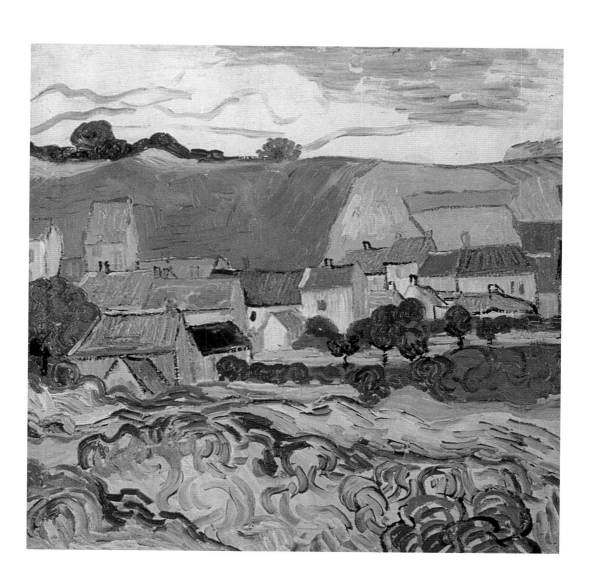

Wheatfield with Crows

July 1890

Oil on canvas, 50.5 x 103 cm
Van Gogh Museum, Amsterdam

"We live in the last quarter of a century which like the previous one will end in a violent revolution. But assuming we both live to see the beginning at the end of our lives—we will certainly not live to see the times of bright skies and a renewal of the whole of society *after* these great tempests. But it is at least something if one refuses to be deceived by what is false and wrong in one's time and senses the unhealthy hollowness and oppressiveness of the hours before the storm." These thoughts of Van Gogh, written to Theo in February 1886, are both stark and prophetic; his brother found them difficult to understand. Towards the end, his letters increasingly contained sentences that are hard to interpret precisely, and often seem despairing, including the famous statement in his very last letter to Theo, dated 23 July 1890, the day he shot himself: "I had intended to write to you about many things, but firstly I no longer want to and secondly I sense how useless it all is." What had happened? In a mysterious mixture of clear-sightedness and insanity, Van Gogh made an attempt on his life, perhaps because he wanted to relieve his brother of the responsibility of caring for him—but perhaps, too, because he was afraid of being abandoned yet again. During a walk through the fields the artist shot himself in the chest and died two days later, on 29 July 1890, at half-past one, stretched out on the bed in his room, with a pipe between his teeth and chatting with Theo. A few days later, on 5 August, Theo wrote to their despairing sister, Elisabeth: "I experience it rather as one of the greatest cruelties of life; we must count him among the martyrs who die smiling."

For Van Gogh, this picture expressed "what I see as healthy and heartening in country life." But the stormy sky with its shades of blue interspersed with black can also be interpreted as a visible representation of his mental state. The work has repeatedly been seen as a sort of "artistic and personal testament" by Van Gogh, though an acquaintance from his time in Etten remembers that Van Gogh repeatedly "painted crows … that are struggling forward against the storm."

In one of his last letters, addressed to Theo and Johanna, Van Gogh wrote: "I too still felt very sad-dened, and had continued to feel the storm that threatens you also weighing upon me. What can be done? – you see I usually try to be quite good-humored, but my life, too, is attacked at the very root, my step also is faltering." He had clearly turned to face his fate—a fate he had possibly hinted at in the threateningly dark sky of this image.

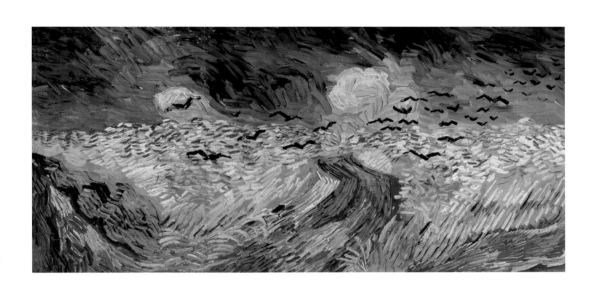

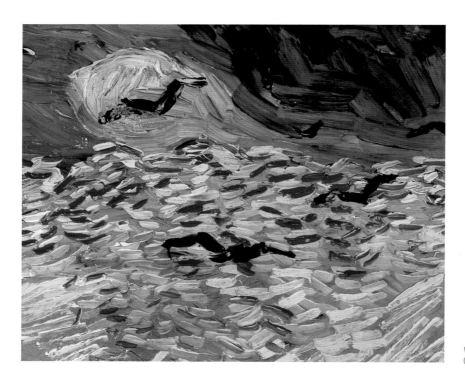

Wheatfield with Crows
(details)

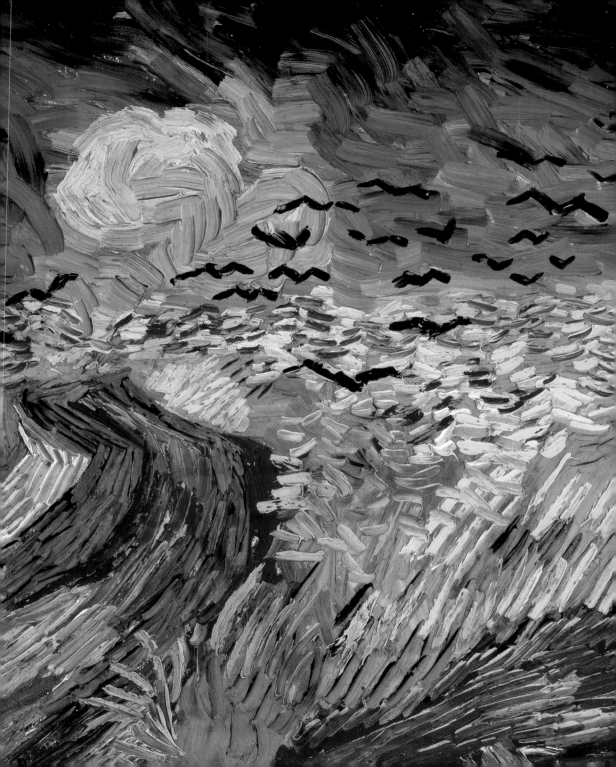

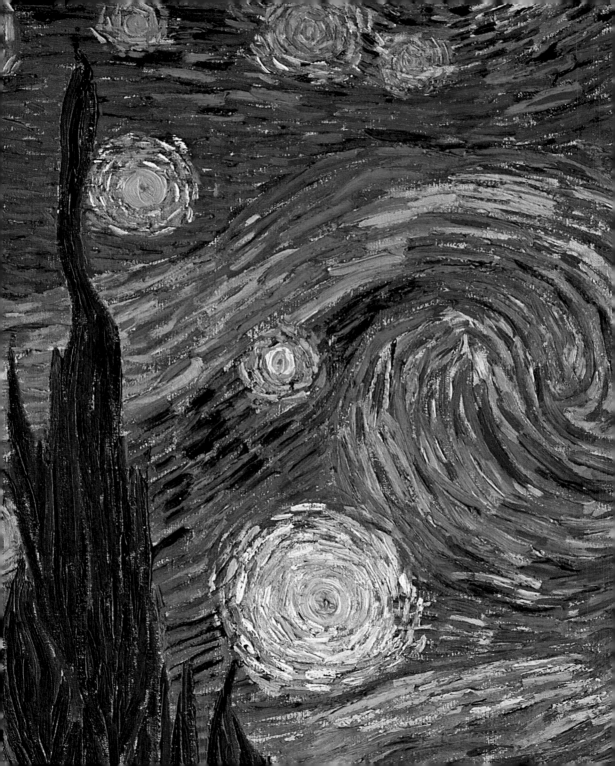

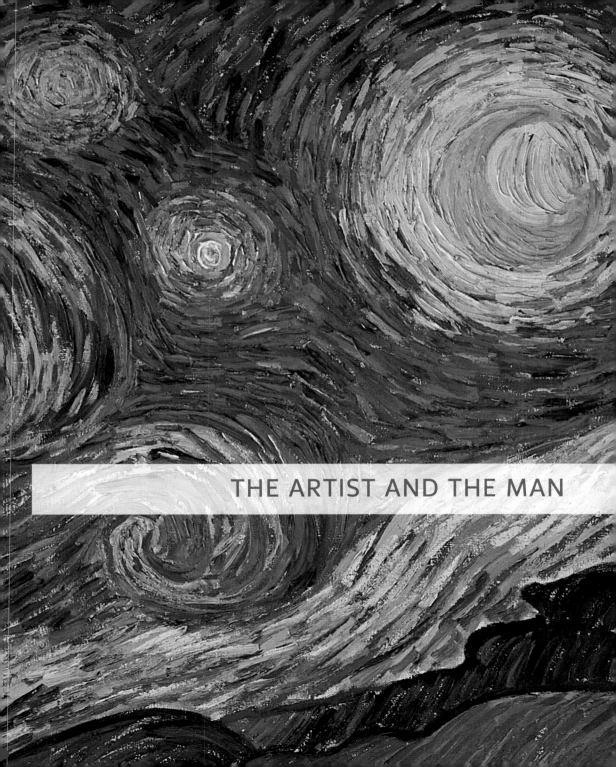

THE ARTIST AND THE MAN

Van Gogh in Close-Up

"Above all, my aim is to represent life." Even though he joined forces with the Impressionists at one stage, Vincent van Gogh remained isolated as an artist and a man. He rejected the rules of traditional painting and attempted to discover what he considered to be the deeper truth of things. With the disarming openness we normally find in a private diary, the pages of his voluminous correspondence provide us with a picture of Van Gogh that shows him as a painter who was basically self-taught (in the various art schools he attended he never managed to stay for more than a few months) and a convinced revolutionary in art. Even during the early years he declared that he was not in the least interested in learning how to draw a head "with mathematical precision," but in how to capture "the depth of its expression … in short: life." With this aim Van Gogh consciously positioned himself outside the established, traditional concept of painting.

To his artist friend Anthon van Rappard, who had strongly criticized *The Potato Eaters* because he found the painting style too non-conformist, he coolly replied that the depiction of a figure according to the rules of the Academy "would not do justice to the requirements of modern painting." He asked why it was necessary to idealize a picture of a peasant; such a painting, he insisted, should give off the "smell of bacon, food and wine, of potatoes." The men and women eating potatoes beneath the lamp, with the rough hands with which they have been digging away at the soil, should "remind us of a very different lifestyle [from] ours, from that of educated people."

Here art is linked to a message: art should evoke emotions. That is why it was important for Van Gogh not to paint things as they appear, objectively speaking, but rather as *he* saw them, transfigured by his emotions. That too leads to "untruths, but to untruths that are truer than the outwardly visible truth." He loved paradoxes, and so maintained that "if you photograph a man digging, then he would certainly not carry on digging"—he would become frozen in time. His ideal was rather to paint the peasants in action, to give the impression of "the air that flows into the lungs of the field worker who has just straightened up in order to catch his breath or to say something." In this, he believed, lay the "essentially modern—the real heart of modern art, that which neither the Greeks nor the Renaissance nor the old Dutch school did." As he clearly stated: "What I aim to achieve is not the drawing of a hand, but the gesture it is making." The mistakes and formal imprecision, the stylistic imperfections, the awkwardness that can frequently be found in his paintings and drawings—and which shocked the critics of his own day the most—are "sins" committed knowingly, deviations that academic painters would never allow themselves because in their painting mere technical skill had replaced genuine creativity. Van Gogh on the other hand could not be anything but creative. In September 1888, he wrote to Theo from Arles that he had always managed quite well in his life and in art without God, but that he had never been able to deny something that was bigger than he was and that governed his entire life: "the strength to create."

Creating form with colors alone

"My brushwork does not keep to any one particular technique," wrote Van Gogh to the painter Émile Bernard from Arles in April 1888: "I thrust irregular brushstrokes onto the canvas and leave them as they are. Thick dabs of paint,

bare patches of canvas, here and there a completely unfinished section, overpainting, roughness; in short the result is, I'm afraid, pretty disconcerting and annoying and will by no means satisfy those with established opinions about technique." There must have been a lot of people like that in France during the late nineteenth century. Paul-Eugène Milliet, a second lieutenant in a Zouave (Algerian infantry) regiment, whom Van Gogh recorded for posterity in October 1888 in Arles in a now famous portrait, declared after the painter's death: "This man, who was endowed with a great deal of taste and talent in drawing, became quite abnormal as soon as he took up a paintbrush. He painted so sketchily and did not bother in the least about the details." Half surprised and half annoyed, he continued: "He never made any preliminary sketches ... he had replaced drawing by color." For Van Gogh that was one of the most important goals he wanted to achieve with his painting—"start the drawing with color," as he wrote. For second lieutenant Milliet, however, this was almost a scandal.

Van Gogh was—in his life as in his art—someone who always swam against the tide, and so he did not find it hard to avoid attachments of all kinds. Even in his painting technique he was never an "imitator," someone who painted "in the style of ..." He was fascinated by the painterly style and the color of Rembrandt, Eugène Delacroix, and Peter Paul Rubens, as well as by that of contemporaries such as Adolphe Monticelli and Jean-François Millet, as he repeatedly admitted; he also owed a debt to the Japanese masters, in particular to their clearly defined forms and areas of flat, even color. Yet his art always remained personal and highly original. He painted quickly and vigorously,

the forms bold and definite, the colors strong, and brushwork expressive. He seldom reworked a painting later, preferring to start the same motif again on a new canvas. His approach had developed early in his career. An eye witness from his time in Nuenen (1884–1885) reported that, once he had started to work, Van Gogh "did not stop again until he had finished what he set out to achieve ... He worked in a great hurry, using broad, powerful brushstrokes. He never corrected anything and he never returned to the same pictorial element."

The color schemes of his most famous paintings show a clear debt to the Impressionists, but even during his time in Paris Van Gogh remained true to the thick, expressive method of applying paint he had used during his time in Holland. And although he was repeatedly inspired by the airy, descriptive "technique" of Claude Monet or Alfred Sisley, for example in *The Bridge at Asnières* (Bührle Collection, Zurich), or by the dry, precise Pointillism of Georges Seurat or Paul Signac, as in his *Interior of a Restaurant* (KröllerMüller Museum, Otterlo), it was above all to prove to himself that he was in a position to work with any sort of technique. And so he was able to report with great relief to his sister Wilhelmina from Arles in June 1888: "In my own technique I have the same ideas concerning colour [as the Impressionists] ... Cornflowers with white chrysanthemums and a few marigolds. There you have a motif in blue and orange. Heliotrope and yellow roses, motif in lilac and yellow. Poppies or red geraniums in bold green leaves, motif in red and green. There you have the *basics* ... enough to show you ... that there are colours that make each other shine, that make a *couple*, complete each other like man and wife."

Van Gogh painted on both canvas and wood. He did not always demand the highest quality in his materials, especially as he was always in straitened financial circumstances and so repeatedly had to make do with what was available, in other words with whatever friends gave him. He preferred lightweight canvases, which he sometimes primed with a white ground (white lead) or with colors mixed with white.

However, he had very precise ideas about the *texture* of the paints, for instance, which proves that, contrary to the common assumption, he was fully aware of the technical aspects of painting. "It seems to me that the more finely a color is ground, the more oil it absorbs. Now, we are not very good with oil; that is obvious. If I were to paint like Monsieur Gérôme [academic artist Jean-Léon Gérôme] and the other gentlemen who aim at photographic accuracy, I would no doubt want to have very finely ground colors. On the other hand, I rather like it when the picture looks a bit rougher. When, instead of grinding the pigments for God knows how long on a stone, one were to rub it for as long as is necessary to make it usable, no longer bothering with the fineness of the grain, then one would have fresher colors that perhaps would not darken quite so easily afterwards." But he also knew of the difficulties that can arise with coarse-grained paints and advised his brother Theo to air paintings that had not dried out properly as much as possible, for "if you keep the colors shut up in the dark, they spoil."

He always worked directly in front of the subject, never from memory. What was most important for him was to record the feeling that the subject evoked before his eyes "directly," and to record its essence in the drawing. He created forms with "more or less clear, always perceptible outlines," as he wrote from Arles, and then filled the areas between with colors that were as simple as possible. Accordingly, "the earth," for example, "always has the same shade of purple, the sky is always blue and leaves are bluish-green or yellowish-green."

One day, when his friend Émile Bernard invited him to his house in Asnières, Van Gogh arrived with a huge canvas. He put it on an easel, divided the area into large rectangles and painted a whole series of landscapes. Returning home, he cut the canvas—by now completely covered with paintings—into individual rectangles and stretched each one on its own frame. Bernard's puzzled comment was that this was "a very strange way of painting, at least a very unusual one." In the ecstatic haste with which he applied the paint, he often squeezed paint onto the canvas directly from tubes and then modeled the paint with his brush. He claimed that this was the method he had always employed. In a letter from The Hague dated the end of August 1882, he described to Theo in great detail how one evening he succeeded in painting trees (the picture has been lost): "Yesterday evening I worked on a wooded area on rising ground, which was covered in dry and rotting beech leaves." "I noticed," he wrote a few lines later, "how firmly the trunks were anchored in the ground; I started to paint them using my brush, but because the ground was already made up of such thick paint my brushstroke sank into it and disappeared, so I pressed the roots and trunks directly onto it out of the tube—and then modeled them a bit with the brush." He finished his account with the words: "In some ways I'm glad I never learned to paint. Perhaps if I had I would have learned how to avoid effects like these."

Paris and the Impressionists

In one of the last letters Van Gogh wrote to Theo before leaving Antwerp, he expressed the wish to study painting in the studio of Fernand Cormon, "where, as you say, there are excellent young people." He wanted to improve his technique by "drawing from nude models and from classical models." A few days later, Theo accordingly introduced his brother to Cormon, who, though a mediocre painter, was an able and very patient teacher. He had set up a private art school in his large studio on Boulevard de Clichy that primarily provided a workplace for young artists who had been rejected by the Academy or who had no studio space of their own in which to work.

Van Gogh managed to stay at the École Cormon for several months, as he remembered "three or four," but he found the training "not as useful as I had hoped," as he later observed, no doubt with good reason. Because what he really needed he could find in the streets of Paris, on the banks of the Seine or in the Bois de Boulogne, in Montmartre or in the surrounding countryside. In these places, recorded for posterity by the Impressionists, what Theo had described to him by letter—the bright, pure colors of the new style of painting in which shimmering light was the basis of a new view of reality—he could now see for himself. So he soon abandoned the somber colors that had characterized his paintings in Holland. The colors became brighter and clearer and he now covered his canvas, initially somewhat hesitantly, with brushstrokes in pure colors that he placed side by side without mixing. Inspired by these exciting discoveries, he created a series of still lifes, especially vases of flowers, and a number of street scenes of Paris: the Bois de Boulogne, the mill at Le Radet, the windmill at La Galette, the Pont du Carrousel, and the Louvre, as well as various corners of Montmartre. These first Impressionist attempts, produced during the spring and summer months of 1886, were followed by a form of expression and stylistic execution that became progressively clearer and more convincing. For Van Gogh had now met the most important representatives of the new art: Monet, Sisley, Edgar Degas, Pierre-Auguste Renoir, and Camille Pissarro. Theo had introduced him to them in the art gallery on Boulevard Montmartre that he ran on behalf of the Boussod and Valadon gallery (which was the successor to Goupil), where many Impressionists exhibited their works. Vincent was delighted when Pissarro explained to him both the theory and techniques of Impressionism, and was fully convinced.

It was also Pissarro, one of the intellectual leaders of the movement, who explained some years later that he had sensed at once that Van Gogh "would either go mad or leave Impressionism far behind him." At that stage he did not know, as he himself admitted, that both predictions would come true.

In the meantime, Van Gogh continued along his chosen path with remarkable determination and dedication. The paintings he produced at the end of 1886 and in the first months of 1887 are so colorful and full of light that it is sometimes difficult to distinguish them from those of the major Impressionists. The Paris art scene had accepted him as one of their own, and that gave him a great deal of satisfaction and a new confidence. He was full of enthusiasm for everything; every new experience excited him; he wanted to meet as many artists as possible, exchange ideas and discuss art with all of them.

1887: the turning point

Having met through Père Tanguy, Van Gogh and Paul Signac often went to paint together in Asnières, a suburb of Paris on the Seine, and it was there, in the summer of 1887, that Van Gogh painted some of his most successful landscapes. Signac later recalled such occasions: "Yes, I met Van Gogh in Père Tanguy's shop. I also met him several times in Asnières or in Saint-Ouen; we went to paint by the Seine, and then we breakfasted in a country inn and returned to Paris on foot ... Van Gogh wore a blue metalworker's overall; the sleeves were always spattered with paint. Sometimes he clung to me and gesticulated violently as he spoke, waving his huge, wet canvas around and smearing himself and the passers-by with paint." Clearly Van Gogh had not abandoned the unconventional, sometimes bizarre behavior that was typical of his unstable character.

During the winter of 1886–1887 his often extravagant behavior and his inexplicable outbursts produced their first victim: cautious Theo, who suffered greatly as a result of his brother's hectic lifestyle, had a nervous breakdown that confined him to his bed for some time. Theo reported to their sister Wilhelmina on the straitened circumstances under which he was living because of Vincent: "No one wants to visit me any more because Vincent starts an argument with everyone; and in any case he is so untidy that our apartment is anything but welcoming ... You could be forgiven for thinking that there are two people living within him: a wonderful, talented, pleasant and gentle person and a merciless egoist."

The summer of 1887 marked a turning point in Van Gogh's life: suddenly there are no more scenes of Paris (the last was *Interior of a Restaurant*, 1887, KröllerMüller Museum, Otterlo). In addition to the still lifes, a constant in his output, he now painted self-portraits intensively, producing at least twenty-one within the space of a few months. He was clearly no longer interested in Paris, his friends and fellow-artists. Even if he admitted that "there is only one Paris," he started to feel uncomfortable there, to feel that he did not belong. He was annoyed above all by the combative attitudes of the artists and especially by the polemic disputes that followed the eighth and final Impressionist exhibition in May 1886. Van Gogh had viewed the exhibition with the enthusiasm of a new convert, but had never allowed himself to be drawn into the dogmatic quarrels of the participants, who from then onwards would go their separate ways. He broadly adopted the theoretical basis of Impressionism but did not follow any specific direction. Instead, he endeavored to use the method in his own way. In any case it would not have suited his character to join a group or to conform to others. Later, when Paris was already far away, he described the collapse of the Impressionist movement in terms of the "devastating civil wars" between its supporters, who "attempted with a fiery enthusiasm to scrape the butter off each other's bread."

But there were problems "at home" too: during the colder months Vincent found himself compelled to spend more time in the apartment, where he repeatedly started quarrels with his brother, accusing him of not doing enough to make his pictures famous, and of being totally dependent on the will of the gallery owners. It is true that Boussod and Valadon gave the manager of their gallery very precise instructions, and these did not include selling works by his brother. Another move was inevitable.

It was apparently Henri de Toulouse-Lautrec, whom Van Gogh knew from his time in the studio of Cormon, who first told Vincent about Provence during their joint sorties into the nightlife of the Paris underworld. If he really wanted to experience the sun, there was no better choice than Provence with its intense, dazzling light and brilliant colors.

As in a dream

During the late afternoon of 20 February 1888, Van Gogh alighted from the Paris train at the little station of Arles in Provence. It was bitterly cold; the dark sky presaged snow, yet he was unconcerned. He was exhausted from the long journey and yet happy that the plan that had begun to obsess him during his last months in Paris had finally become a reality. What had made him decide to escape from Paris—and it really was an escape—was his fear of becoming imprisoned within forms that he no longer "felt." The ideological discussions and heated disputes between the Impressionists had disappointed and exhausted him, even though he never took a leading part in them. Looking back later he would write: "Since the interpretations [of the Impressionists] are so different and in some respects irreconcilable, it will not be Impressionism that defines the laws [of color]." It was better, he knew, to make his own way independently.

On the day after he arrived he wrote to Theo: "I have discovered a wonderful red patch of ground planted with vines, with mountains of the most delicate purple forming the backdrop. And snowy landscapes with white mountain tops against a sky that is as brilliant as the snow—it is like the winter landscapes of the Japanese." The new impressions excited him; he had only one thing in mind: to paint. With the same enthusiasm with which he had applied himself to adopting the artistic message of Impressionism two years previously, he now tried to capture the light and the colors of the Provençal landscape. As spring approached, he felt as if newborn: "I'm working furiously because the trees are in blossom and because I want to make a Provençal orchard of immense colorfulness." From March to May he walked back and forth in all directions across the area around Arles and brought back with him at least twenty paintings of blossoming peach, cherry and apple trees, "blazing clouds" that contrast with the intense green of the background and the blue of the sky. He felt at ease, free, inspired: "In such moments," he wrote, "I can see with alarming clarity, when nature is as beautiful as it is in these days, and then I can no longer feel myself and the picture comes to me as in a dream."

His work monopolized him ("I think I'm really a worker and not a stupid foreigner, not a tourist who is traveling around for his own pleasure"), but not to such an extent that he did not mourn intensely the death of Anton Mauve, who had been his "master" in The Hague. He dedicated one of his landscapes to him, *Peach Tree in Blossom* (today in the Kröller-Müller Museum, Otterlo); it was "the best study I have done here," he assured his brother, continuing: "I don't know what they will say about it at home, and I don't care; I felt that it had to be something delicate and at the same time as colorful as a memory of Mauve." And at the end he quoted the poem: "Do not think the dead are dead. / As long as there are men here who live, / The dead will live on, the dead will live on."

During the spring and summer of 1888 he produced a large number of still lifes, among which the series of sun-

flower pictures occupies a prominent place. But there were also landscapes, blossoming gardens, meadows and cornfields under a parchingly hot sky, and views of Arles. He also painted a number of portraits: Roulin the postmaster and the members of his family; Madame Ginoux; Milliet, second lieutenant in a Zouave regiment; and the peasant Patience Escalier. They were the few friends on whom Van Gogh could count in an otherwise hostile environment. For this strange individual, who spent his days smearing paint on canvases instead of working, was regarded with suspicion. He felt that such hostility and suspicion affected his work, and in September he wrote to his brother: "I still feel I'm being repeatedly robbed of my best opportunities because I have no models, but I take no notice—I focus my attention on the landscape and color without bothering about where it will lead me."

Growing pessimism

A sudden change in the weather in the fall afflicted him deeply ("I fear that it will make me melancholy," he wrote to his brother in September 1888), but he was firmly convinced that the problem would be resolved by the arrival of Paul Gauguin, which after a great deal of discussion and delay had been arranged for 20 October. For Van Gogh this was the first step toward the "Atelier du Midi" that he had been dreaming of for some time—and with which he had been constantly badgering his poor brother Theo. It was to be a community of painters who had come together to work with the aim of creating a completely different kind of art. Van Gogh was, of course, being completely unrealistic when he assumed that Degas, Monet, Pissarro, Sisley, or Renoir would contribute

"their own fame for the benefit of the new members" within the community!

But at least Gauguin came. Van Gogh, however, was now utterly exhausted: since his arrival in Arles he had been working "like a madman, in desperation," for he was desperate to prove his originality to Gauguin: "I have the ambition to make a certain impression on Gauguin with my work," he wrote. During the last few weeks he had worked almost without rest. But his superhuman efforts led nowhere. Initially, the two artists worked well together, exchanging opinions and giving each other advice. But soon there were disagreements and then direct confrontations that became progressively more violent. On 23 December a dramatic break occurred and Van Gogh suffered a nervous breakdown; he mutilated his left ear, and a short while later he was admitted to the hospital in Arles.

It was during this time that he painted the symbolic pictures that depict his own chair, with pipe and tobacco, and—even more hauntingly—Gauguin's chair, with an extinguished candle and books. In effect, these two paintings are portraits, which "in their emotional and psychological dimension prophesy the loneliness of Van Gogh." From this time on, Van Gogh's life led steadily downhill into a state of total isolation and emotional turmoil that assumed ever more threatening traits.

But he also underwent a rapid transformation as an artist. His painting was no longer characterized by the dazzling sun and its bright power. The light had lost its radiance, the tone was now more muted, deeper. An unmistakable hint of melancholy was mixed into his colors. And yet the few landscapes he painted during the early months of 1889—such as *Orchard in Bloom* (Neue Pinako-

thek, Munich]—show an unusual serenity that is linked to a boldness of conception he had achieved in virtually no other painting previously.

At the beginning of May 1889 Van Gogh left Arles and was admitted to the nearby mental asylum in Saint-Rémy. When his health allowed it, he painted landscapes (especially those featuring olive trees), still lifes, peasants, a few portraits, and copies after Delacroix, Rembrandt, and especially Millet. (These were not really copies but highly individual versions; they were based on engravings or black-and-white photographs and so he had to invent the colors for himself.)

During these months a fatal pessimism increasingly dominated his letters: "The melancholy often overwhelms me very powerfully," he confessed hesitantly to Theo. He felt completely alone, and the isolation had a devastating effect on his mood and his confidence.

Concerned about his poor state of health, on 20 May 1890 Theo had his brother brought to Auvers-sur-Oise, about 30 kilometers northeast of Paris. He hoped that such a radical change of environment would have a positive effect on Van Gogh's health. And indeed he did begin to take an interest in the new landscape. The new pictures piled up with breathtaking speed in his room in an inn: still lifes, portraits, countless views of Auvers and the surrounding areas, notably the village church and cornfields painted with dense, glowing yellows. He wrote to Theo: "There are endless cornfields beneath a cloudy sky, and I was not afraid of the attempt to express sadness and extreme loneliness." In these paintings we can almost hear the artist's cry of anguish and the premonitions of a psyche that had suffered a mortal injury.

The drawings: genius and originality

Van Gogh started painting late. It was not until the end of 1881, at the age of twenty-eight, that he produced his first, often rather tentative, oil paintings—at an age by which his famous compatriot Rembrandt, for example, had already produced some of his major works, including *The Anatomy Lesson of Dr. Nicolaes Tulp*. However, when Van Gogh finally turned to painting he had already been drawing for a long time. He had started in his home village of Groot Zundert, even before his ninth birthday, when he drew on a single sheet a dog and the head of an ox, as well as the faces of three men. Judging by the sheets that have survived, these were followed that same year by three more dated and signed drawings, including two copies after drawings by Victor Adam, a French painter and lithographer: *The Bridge* and *Barking Dog*. These early drawings reveal remarkable technical maturity for a child of this age, as well as a sureness of line. Van Gogh continued to draw during the years that followed, in other words during his schooldays and then later in The Hague, Paris, Brussels, and London, the cities to which his job as an employee of Goupil the art dealers took him. Even during his time as a fledgling lay preacher and then during the crisis in southern Belgium, as well as in the remoteness of the northern Netherlands, he continued to draw.

Very little has survived of the works from these years, because Van Gogh was very disorganized and at the time had no thoughts of becoming a "professional" artist—a decision he finally took only in despair, when he realized he would not be a preacher. And so neither he nor his parents thought of keeping his drawing exercises. It seems likely that he himself destroyed them and that many were

thrown away as waste paper during the numerous moves his father had to make when he was sent to another parish. So it is not surprising that, for example, not a single sheet has survived that is either dated to the period between 1865 and 1872, or that can be attributed to this period; and for the years from 1873 to 1879, just twenty drawings have survived.

We therefore have a regular documentation of Van Gogh's drawings only from 1880, in other words from the point when he settled in Brussels and declared to his brother that he had decided to devote his life to painting. A very wide-ranging collection of drawings has survived; in fact, in terms of quantity, it is at least the equal of his paintings. The catalogue of his graphic works lists 908 entries (including nine lithographs), with a large number of the sheets having drawings on both sides: he did not want to waste any paper.

Van Gogh employed a number of media, extending from pencil and charcoal to pen and reed pen (which he adopted from Japanese art), creating drawings he often "completed" with the addition of wash. In all these media, his drawings—even the earliest—reveal the highly individual, sure hand of a great master. In most cases they are sketches and preparatory studies for his paintings. Sometimes he worked with obsessive determination on one and the same subject: we need only think of the studies of heads and hands he produced before the final version of *The Potato Eaters*, or the incredible number of drawings of pairs of working peasants, bending over in the fields, that he produced in 1885 in Nuenen. But there were also copies of paintings of "his" masters, especially Millet, whose famous *Angelus*, for example, he copied in a drawing that can be found today in the Museum KröllerMüller in Otterlo. There are also the many roughly executed drawings with which Van Gogh illustrated his letters to his brother Theo. On many occasions, however, the drawing was an independent work executed for its own sake. These include a portrait of Van Gogh's father that he drew in July 1881 in Etten from a photograph of Pastor Theodorus. It consists of a few—one might even say merciless—strokes (Van Gogh could not be expected to idealize anything), which nevertheless capture the essence of man's character. Further groups of independent drawings include images of his father's garden in Nuenen, the remarkable views of Paris from the years 1886–1888, and the moving landscapes from his last period in Saint-Rémy and Auvers, in all of which he captures the nature of his subjects with extraordinary skill. As in some of his paintings, so in a few of his drawings an imaginary space replaces the real one. This applies, for example, to the ink drawing *The Canal Roubine du Roi with Washerwomen* (private collection), which he painted in June 1888 in Arles. Here he superimposes two view points, one for the landscape in the background, which is represented according to the rules of conventional perspective, and the other for the canal and its banks, for which he chose a much higher angle. Here, too, we can say that for Van Gogh reality was to be found not in the external appearance of things, in a "vague recognition of forms," but in "emphasizing … the unique features … that lead to the fact that a specific object is like no other." This unconventional approach was without doubt one of the reasons why the professors at the art academy in Antwerp rejected the drawing that Van Gogh had submitted in March 1886 for admission to the advanced course.

Heart-rending confessions

It would probably not be possible fully to understand Van Gogh's life as an artist and a man if his wide-ranging correspondence had not survived; in effect, it forms a diary to which he confided his true thoughts throughout his career. The 821 letters were written between 1873, when he was twenty, and 1890; the dead man still carried with him the last letter, which he had written on 27 July, the day of his suicide attempt. Thousands of closely written sheets of paper, often with sketches and drawings, form a distinct aspect of Van Gogh's oeuvre. He confided to his letters poignant confessions and analyses of his own works (and those of others), making them an unremitting and courageous exploration of his life and art, of his passionate enthusiasms and bitter disappointments, of his acute loneliness and gradual disintegration. They were an essential emotional outlet for a moody, lonely individualist who felt compelled to reach out to others, to communicate with them, but whose shy, introverted nature prevented him from finding sympathy and friendship and whose aggressive attitude repeatedly caused offence or alarm. He very seldom enjoyed real friendships; those he did have were typically intense but short-lived. In letter writing he found a form of expression that enabled him to communicate with others without over-taxing those who had decided to remain in contact with him. His most important confidant was his brother Theo; he wrote him no fewer than 668 letters. The recipients of the others were his artist friends Anthon van Rappard (58) and Émile Bernard (22), his sister Wilhelmina (22), his mother or his parents (16), and his friends from the hotel in Arles, Monsieur and Madame Ginoux; the painters Paul Gauguin, Paul Signac, Eugène Boch and Horace Mann Livens, his uncle Cornelius, his sister-in-law Johanna, postman Joseph Roulin, and a few others.

This intrinsically complex source material is in effect an autobiography, albeit a very original one. That, however, does not make it any the less authentic, profound and serious. It vividly conveys the image of a man who was torn by inner conflicts but who nonetheless possessed a certain good-naturedness. Thus he wrote to Theo in March 1883: "One might think that in every human being there must be that human kindness that is the basis of all things. But some behave as if there were better principles. I for my part don't want to know about that: if the traditional ones have proven themselves for some time to be right, that is good enough for me."

Forgeries

In December 1928, a few months after publishing his monumental catalogue raisonné of Van Gogh's works *L'Œuvre de Vincent van Gogh*, the writer and art critic Jacob-Baart de la Faille issued a supplementary volume in which, in an act of admirable courage and honesty, he listed as fakes thirty-three paintings that he had recorded in his catalogue as original works by Van Gogh. As might have been expected, this initiative on the part of de la Faille sparked off a real panic in the art market and great astonishment on the part of the art critics: on the one hand this self-correction by the art scholar demonstrated incontestable seriousness and moral rectitude, but on the other the discovery that dozens of fakes were circulating sounded the alarm for dealers, gallery owners, museums, and private collectors.

It transpired that it was not really that difficult to fake a good Van Gogh, given that even specialists had fallen into the trap. In fact there were several reasons why Van Gogh really had made it easy for forgers: he often painted the same subject five or six times, so that a "new" variation on a well-known motif would come as no surprise; he had worked in many places and his works were widely dispersed; and finally, as so few of his works had been exhibited or sold, the question of provenance was often very problematic.

Moreover, the poverty-stricken life Van Gogh led was as erratic as it was disorderly, and he himself was ultimately not really interested in what happened to his paintings, with the exception of those he sent to Theo. When he left Arles in May 1889 to go to Saint-Rémy, he gave the staff in the mental hospital and his few remaining friends the pictures that he had painted during the previous weeks.

What happened to the paintings and drawings that Van Gogh left in Nuenen when he moved out of his parents' house was equally incredible: his mother and sister packed them up and stored them with a dealer in Breda. The latter later sold them all as a job lot to a junk dealer, who rigorously sorted out the works he considered to be without value and difficult to sell, and kept only those which he thought could be sold. He got rid of the ones he thought weak simply by burning them and sold the rest to a tailor called Mouwen in Breda at ten centimes each. Of course no one knows which or even how many of Van Gogh's paintings were hung on Mouwen's walls, but it is fairly certain that some of them are still in circulation.

Afterlife

As one of the great artists of the modern age, Vincent van Gogh's story did not end following the tragic episode of 1890. Since then he has been celebrated in countless important retrospectives and a magnificent museum has been dedicated to him in Amsterdam. Opened in 1973, it soon acquired an outstanding reputation. It is a place in which visitors can experience the works at close hand, many of which belonged to the "fine selection," as Theo described the collection in 1886 that the two brothers had compiled jointly. Van Gogh continued to have an influence on artists through his expressive style and his utter commitment to his art; his impact on the development of modern art was huge. Writers and filmmakers have also been drawn to his intense and dramatic life—two celebrated films are Vicente Minnelli's *Lust for Life* (1956) and Akira Kurosawa's *Dreams* (1990).

In his entire life he sold just one picture

"I would count myself very happy if I could earn enough to support myself," wrote Van Gogh on 9 May 1889 to his sister-in-law Johanna from Saint-Rémy, adding: "It worries me greatly that I have produced so many pictures and drawings without selling any of them." With this quiet sigh of regret—perhaps the saddest and most affecting passage in his extensive and rich correspondence—Van Gogh summarizes two tragic aspects of his life as an artist and as a man: on the one hand the incomprehension of the public and the hostility of the critics and art dealers, which made it impossible for him to support himself with his work; and on the other the humiliating circumstance of having to depend on the support of his family, especially his brother Theo.

He always felt under an obligation to his brother, who paid him an "allowance" of 100 to 200 francs a month, to justify his expenses down to the last centime, as well as the unforeseen costs that forced him to tighten his belt and ask for more money. "While I could manage with 100 francs a month for myself," he wrote to Theo at the end of January 1882, "it's quite another matter when I also have to pay and feed my model every day, etc. etc. And then there are the expenses for paint, paper, and so on." Six years later, in August 1888, his situation had not changed. He asked Theo for money yet again, explaining that if his painting were not supported he would have only "the choice between being a good or a bad painter. I choose the first. But painting makes demands like an extravagant mistress who destroys you. Without money you can do nothing, and you never have enough." And he expresses the bitter wish that "painting should be carried out at the expense of society and not of the artist," in order to give the artist the freedom he needed.

If it were not so tragic, we could easily consider the following confessions to be melodramatic. "As I have already told you," he wrote to his parents in February 1881, "about four weeks ago I bought myself a pair of trousers and a coat from a second-hand dealer. I liked them so much that I bought another coat and another pair of trousers from the same man. Admittedly, with the first things I bought I would have had more or less enough, but if you have two outfits it is really better, and they do not wear out so quickly because you can wear them alternately ... But do not concern yourselves about these expenses and think that I am frivolous, because really my fault is the very opposite ... If you can send me some more

this month without having problems yourselves, I should like to ask you to do so. But if you can't, there's no hurry at the moment." When Theo informed him in February 1890 that he had sold his painting for 400 francs he was almost beside himself with joy. The picture in question, *Red Vineyard*, had been exhibited with five others in the Salon des Vingt in Brussels; the other pictures exhibited were: two *Sunflowers* (both 1888), *Tree Trunks (Ivy)* (1889), *Flowering Orchard* (1889), and *Wheatfield, Sunrise* (1889).

Les Vingt (The Twenty) was an association of artists and writers who regularly organized exhibitions at which paintings by especially famous artists were on view, as well as those by painters who in their opinion deserved special attention. Of course Van Gogh belonged to the second category, because the other invited artists were Cézanne, Toulouse-Lautrec, and Renoir, who were already well-established by that time.

In the first years after Van Gogh died, no official sales of his pictures were recorded; the first documented sale took place in 1900, when a still life changed hands for an amount equivalent to about $270 today. But by 1911 the Kunsthalle Bremen purchased *Field of Poppies* for 30,000 Goldmarks. And from then onward the prices for works by Van Gogh rose higher and higher in an extraordinary way as his life and art made him universally famous. In 1990 the *Portrait of Dr. Gachet* was sold at Christie's in New York for $82.5 million.

Anthology

Nonetheless, in the case of Vincent van Gogh I believe, despite the sometimes baffling strangeness of his paintings, that no unprejudiced person who knows how to look would be able to deny or dispute the naive authenticity, the genuine naturalness of his artistic vision. Independently of this indefinable air of authenticity and of what he has really seen, which all his pictures radiate, it is the choice of subject, the constant relatedness of the most exuberant tones, the conscientious study of characteristic features, the constant search for the essence of every object, a thousand significant details which confirm his profound, almost childlike honesty beyond doubt, his great love of nature and of truth—of what is true in his eyes.

Having admitted that, we may be permitted to draw conclusions from these very works by Vincent van Gogh about his character as an individual and above all as an artist ...

What is specific to his work is the excess—the excess of strength, the excess of sensitive irritability, the violence of expression. In the imperious affirmation of the essence of things, in the often bold simplification of the forms, in the impudent abandon with which he puts the sun before us, in the stormy movements of his drawing and his colors, indeed in the smallest details of his technique he reveals a great masculine nature, a boldness which is frequently uncouth and yet sometimes of naive delicacy ...

However, the profound, diverse, highly individual art of Vincent van Gogh cannot be explained and described only through his reverent love for the reality of things. No doubt like all painters of his ilk he has a strong feeling for the material, for its importance and beauty, but in most cases he regards this intoxicating material only as a kind of wonderful language whose purpose is to interpret the idea. He is almost always a Symbolist. Admittedly not a Symbolist like the Italian Primitives, the mystics, who scarcely felt the need to transfer their dreams from the non-corporeal into the physical; by contrast he is a Symbolist who feels the constant necessity to clothe his ideas in precise, ponderable, tangible forms with an intensively physical, material shell. In almost all his pictures, for a viewer who knows how to see it, there lies beneath this figural shell, beneath their fleshly flesh, beneath this very material, a thought, an idea, and this idea, the foundation of his work, is both its effective cause and purpose at the same time. In Van Gogh's work the shiningly radiant symphonies of his colors and lines—however important they may be for the artist—are nothing more than a mere means of expression, simple methods of allegorical representation. ... And how can we explain this obsession with the disc of the sun which he loves to show in the glowing embers of his sky, and at the same time his passion for that other sun, for that star among flowers, the magnificent sunflower, which he indefatigably repeats as if driven by some compulsion—how could we explain all that if we wanted to dispute that some hazy, brilliant sun myth fills his thoughts and gives them meaning?"

Albert Aurier

Un Isolé: Vincent Van Gogh, Mercure de France, January 1890

More than any other, Van Gogh is always totally personal. He loves the Japanese, the Indians, the Chinese, everything that sings, laughs, vibrates; it was in these artists that he found his remarkable harmonies, the extraordinary flow of his own drawings, as in the depths of his heart he en-

countered the feverish nightmares with which he con-
stantly haunts us ..."

Émile Bernard
"Petit portrait de Vincent Van Gogh," La Plume, Paris, September 1891

Van Gogh was Dutch by birth, from the land of Rembrandt, whom he appears to have greatly loved and admired. If it were at all possible to allocate an artistic parentage to his over-abundant originality, his artistic fire, his over-fine sensitivity, who allowed himself to be governed only by his very own impressions, then perhaps we could say that he saw Rembrandt as his ancestor, that he felt that Rembrandt best lived on in him. In his numerous drawings we do not find similarities, but rather a strong preference for the same forms, the same wealth of linear inventiveness. Van Gogh does not always demonstrate the same correctness and moderation as the Dutch master; but he often achieves his eloquence and his remarkable ability to reproduce life. We have very precise and very precious proof of how van Gogh saw and felt in the copies which he executed after various works by Rembrandt, Millet and Delacroix ... In Millet's *Sower*, which van Gogh reproduced so extraordinarily beautifully, the movement is more emphatic, the vision broader, the line enhanced to become symbolic. What is present of Millet remains in the copy, but Vincent van Gogh has added something of his own, and the picture immediately gains a new greatness. And he certainly also approached nature with the same intellectual habits, the same superior creative talents as in the masterpieces of art. He could not forget his personality, could not keep it in check in the face of any sort of sight, any sort of external dream. His personality flowed in glowing inspiration in everything that he saw and felt. But he did not allow himself to be swallowed up by nature. He absorbed nature himself; he forced it to be compliant, to adapt itself in line with the forms he thought or, to follow his train of thought, even to tolerate his characteristic malformations. Van Gogh possessed to an unusual extent that which distinguishes one person from another: style.

Octave Mirbeau
"Vincent Van Gogh," Echo de Paris, 31 March 1891

The tragedy of his brief life lies in the fact that he spent most of it seeking amidst sorrow, pain and despair after the simplest, the most obvious thing in existence, the sun, and that he died as soon as he had found it. For none of his predecessors had the way been so difficult, the transition of the northern man from the world of literature, of ideas, of morality and social problems to the sensual world of pictures. No one before him had sought so passionately after what he did not possess. One element of the southern clime was innate in his dark and frigid origins; the Mistral, that wind which can lift stones from the ground and carry them away. He had the Mistral in his heart, and borne on its wings he set out to find the rest: the sun and colour.

His life is the story of a great and passionate heart, which was entirely filled with two things: love and sorrow. Love, not in the sense of likings and preferences, of sympathy and aesthetic taste, but in the deepest form, charity, a deep religious relationship to men and things. Here is the root of his art.

Wilhelm Uhde
Van Gogh, 1937

The Impressionist vision of the world could not allow portraiture to survive; the human face was subjected to the same evanescent play of color as the sky and sea; for the eyes of the Impressionists it became increasingly a phenomenon of surface, with little or no interior life, at most a charming appearance vested in the quality of a smile or a carefree glance. As the Impressionist painter knew only the passing moment in nature, so he knew only the momentary face, without past or future; and of all its moment, he preferred the most passive and unconcerned, without trace of will or strain, the outdoor, the summery holiday face. Modern writers have supposed it was photography that killed portraiture, as it killed all realism. This view ignores the fact that Impressionism was passionately concerned with appearances, and was far more advanced than contemporary photography in catching precisely the elusive qualities of the visible world. If the portrait declines under Impressionism, it is not because of the challenge of the photographer, but because of a new conception of the human being. Painted at this time, the portraits of van Gogh are an unexpected revelation. They are even more surprising if we remember that they were produced just as his drawing and color were becoming freer and more abstract, more independent of nature.

In their revival of portraiture, Van Gogh's paintings belong to a sentiment of the individual which is clearly of his time; it would be inconceivable before the 1880s, yet rests on the previous art which had seemed to be the end of portraiture. Vincent's portraits, like Lautrec's, were not commissioned, but a free choice by the artist. They were not destined for the sitter, like the older portraits which celebrated their subject in his social presence and strength, by showing him as a figure of power, profession, and imposing appearance. They are distinguished on the contrary by their openness and outdoor quality; the subjects are for the most part plain people, like the peasants who have attracted the artist by some trait which inspires him. Or, rather, it is not a particular trait that makes them worth portraying, but their humanity alone, their accessibility to Vincent's hunger for friendship and affection.

Meyer Schapiro
Van Gogh, 1969

So it would be wrong to suppose that van Gogh's color – rich and exquisitely lyrical though it is – was meant simply as an expression of pleasure. Moral purpose is never distant, and rarely absent, from his Provençal landscapes; they are utterances of the religious heart, and their central premise, that nature can be seen to reflect simultaneously the will of its Creator and the passions of its observer, is one of the most striking examples of the "pathetic fallacy" in painting. It was also of central importance to later Expressionism. Van Gogh was only thirty-seven when he shot himself, but in the four years from 1886 to 1890, he had changed the history of art. The freedom of modernist color, the way emotion can be worked on by purely optical means, was one of his legacies – as it was Gauguin's, too. But van Gogh had gone further than Gauguin; he had opened the modernist syntax of color wider, to admit pity and terror as well as formal research and pleasure. He had been able to locate more cathartic emotion in a vase of sunflowers than Gauguin, with his more refined Symbolist sense of allegory, had been able to inject into a dozen figures. Van Gogh, in short, was the hinge on which nineteenth-century Romanticism finally swung into twentieth-century Expressionism.

Robert Hughes
The Shock of the New, 1980

The artist 'van Gogh' has become like a site where discourses on madness and creativity converge. Madness and creative genius, both socially constructed as extreme, alienated and aberrant kinds of behaviour, are mapped onto van Gogh, rendering him the 'mad artist' and the subject of a study of creativity as a kind of abnormal psychological phenomenon. Van Gogh referred himself to 'the artist's madness' … eliding his illness and professional identity into a cultural construction. … His physical and emotional suffering, his images read as an identification with the poor, his easily recognizable individual pictorial style, especially in the later works, were co-opted in the course of twentieth-century cultural mythologizing: van Gogh was made into a paradigm of the misunderstood modern artist. Overlapping institutional, critical and cultural enterprises have secured such a paradigm. Ironically, these endeavours involving publicity, exhibitions and the machinery of art scholarship contrast with the image of

the lonely *isolé* they project. In the decades following his death national, ideological and artistic needs formulated differently nuanced van Goghs.

Melissa McQuillan
Van Gogh, 1989

So what *did* he want that art to be? Simple: Vincent van Gogh yearned to make painting that was charged with the visionary radiance that had once been supplied by Christianity. Jesus, he wrote, was an artist whose medium had been humanity. Vincent wanted modern art to be a gospel, a bringer of light, that would comfort and redeem through ecstatic witness. Its mission would be comparable to the Saviour's in that it would connect, intuitively, with the *misérables* – the poor and illiterate, the walking wounded of industrial society. The grim and dusty toil of Everyman and his trudge through life would be turned into a communion with nature, a revelation of the infinite down here; and it would be accessible enough to become part of daily life, as stained glass and altarpieces had been for that older world of belief. Like these windows, this new art should blaze with colour – for colour marked the presence of the divine. The unadulterated colour would have the innocently brilliant intensity of children's art, and it would be laid on in excited short strokes, dashes and coils, simultaneously artful and artless, the kind of strokes we imagine we could make ourselves. The artist's own heightened perception would be translated for the spectator so that we might share in this universe of intense feeling and looking. Modern paintings would be acts of friendship, a visual embrace. 'Yours with a handshake' Vincent signed his letters to his brother Theo. And, in effect, that's the way he signed his work for all of us.

Simon Schama
Van Gogh, in Power of Art, 2006

Vincent Van Gogh paints himself free of self-pity. It does not occur to him to complain. No matter what he endures, no matter what anguish and penury and isolation he suffers, he does not feel sorry for himself in his self-portraits.

This seems counterintuitive. Vincent, as we intimately call him, is surely the most wronged and downtrodden painter in art, a lone soul struggling to sing like a bird while the brutes shoot him down, a misunderstood genius excluded and eventually suicided – as Antonin Artaud said – by society. The passion of his painting equates, somewhat, in our minds with the missionary passion of his life: he is ill but cares for others; he is poor and yet takes the indigent into his home; he preaches a message of hope through the whole of his life without ever being given any reason to hope. He fails as a preacher, his zeal unheeded … Unrequited in love, unrecognized as an artist … he was locked up by public petition as not fit for the liberty of the streets. At his lowest point, desperate for brotherhood, abandoned by the treacherous Gauguin, he finally shoots himself in a field where the black crows caw, unable to walk any more through the shadows of depression. Of all painters Van Gogh is the nearest to martyrdom and the furthest from ego, the one we would most like to protect and the one we would most readily embrace if he chose to lament his lot.

But he never does. Van Gogh is not wretched in his art and he is not a martyr. There may be melancholy and a look of aftershock in the self-portraits from time to time, but he keeps the agonies to himself in the endeavour to make strong paintings. This strength is visible and palpably uplifting yet it has not prevented generations of viewers from believing that they experience his sufferings when they look at his works, that they can hear the fine high notes of Vincent's grief. In that sense, these are the most unexamined – and misunderstood – of all self-portraits…

Laura Cumming
A Face to the World: On Self-Portraits, 2009

Locations

BELGIUM
Brussels
Musée d'Art Moderne
Fishing Boats at Sea, 1888

BRAZIL
São Paulo
Museu de Arte
L'Arlésienne: Madame Ginoux,
February 1890

BRITAIN
London
Courtauld Institute
Self-Portrait with Bandaged Ear,
1889
Walsall
Walsall Museum & Art Gallery
Sorrow, April 1882

FINLAND
Helsinki
Ateneumin Taidemuseo
Village Street in Auvers, July 1890

FRANCE
Paris
Musée d'Orsay
*Terrace of a Café on Montmartre
(La Guignette),* October 1886
Starry Night Over the Rhône, 1888
Portrait of Eugène Boch,
September 1888
Self-Portrait, September 1889
The Bedroom, 1889
*Pine Trees with Figure in the Garden
of Saint-Paul Hospital,* 1889
Portrait of Dr. Gachet, June 1890
The Church at Auvers, 1890

*Noon: Rest from Work (after Millet),
or Siesta,* January 1890

GERMANY
Munich
Neue Pinakothek
Orchard in Bloom, 1889

HUNGARY
Budapest
Szépmuvészeti Múzeum
Peasant Woman Preparing Milk,
1885

ITALY
Milan
Civica Galleria d'Arte Moderna,
Collezione Grassi
Breton Women in a Meadow, 1888
Galleria Nazionale d'Arte Moderna
The Gardener, 1889
L'Arlésienne, 1890

THE NETHERLANDS
Amsterdam
Stedelijk Museum
*Vegetable Gardens in Montmartre:
La Butte,* 1887
Van Gogh Museum
The Sower (after Millet), early 1881
The Weavers, 1884
The Potato Eaters, April 1885
Still Life with Bible, October 1885
The Dance Hall, December 1885
Vase with Autumn Asters,
Summer 1886
*The Hill of Montmartre with Stone
Quarry,* 1886

Self-Portrait with Dark Felt Hat,
1886
*In the Café: Agostina Segatori in
Le Tambourin,* early 1887
*Vegetable Gardens in Montmartre
(La Butte),* April–June 1887
*Courting Couples in the Voyer
d'Argenson Park in Asnières,*
May–June 1887
Trees and Undergrowth,
Summer 1887
The Courtesan (after Eisen),
July–September 1887
*Still Life with White Grapes, Apples,
Pears and Lemons, "À mon frère
Théo,"* Fall 1887
Gate in the Paris Ramp, 1887
Self-Portrait as an Artist,
January 1888
*Sprig of Flowering Almond Blossom
in a Glass,* March 1888
The Pink Orchard, March–April 1888
The Harvest at La Crau, June 1888
*Fishing Boats on the Beach at
Saintes-Maries-de-la-Mer,* June
1888
La Crau from Montmajour, July 1888
The Yellow House, September 1888
The Bedroom, October 1888
The Sower, November 1888
Gauguin's Chair, December 1888
The White Orchard, 1888
Sunflowers, January 1889
Wheatfield with a Reaper,
September 1889
Pietà (after Delacroix),
September 1889
Portrait of a Patient in Saint-Paul,
October 1889

Almond Blossom, February 1890
Irises, May 1890
Wheatfield with Crows, July 1890
Tree Roots, July 1890
View of Auvers, 1890
Otterlo
KröllerMüller Museum
Autumn Landscape with Four Trees,
November 1885
The Langlois Bridge, March 1888
Haystacks in Provence, June 1888
Café Terrace at Night, September
1888
La Berceuse (Augustine Roulin),
January 1889
Cypresses with Two Female Figures,
June 1889
Rotterdam
Museum Boymans van Beuningen
Lane with Poplars, November 1885
Portrait of Armand Roulin,
December 1888

NORWAY
Oslo
Nasjonalgalleriet
Peasant Woman, Kneeling, 1885

RUSSIA
Moscow
Pushkin Museum
Fishing Boats at Sea, 1888
The Red Vineyard, November 1888
Portrait of Doctor Rey, January 1889
Prisoners Exercising, 1890

SWITZERLAND
Basel
Kunstmuseum
View of Paris from Montmartre, 1886
Marguerite Gachet at the Piano,
June 1890
Bern
Sammlung Hahnloser
Field with Crows, 1890
Winterthur
Kunstmuseum
Summer Evening, 1888
Meadow with Yellow Flowers, 1889
Sammlung Reinhart
The Garden of the Hospital in Arles,
1884

USA
Baltimore
The Baltimore Museum of Art
A Pair of Boots, 1887
Boston
Museum of Fine Arts
Portrait of Joseph Roulin, Seated,
July/August 1888
Buffalo
Albright Knox Art Gallery
The Old Mill, September 1888
Chicago
The Art Institute
*Clearing in a Park, the Poet's
Garden*, September 1888
The Bedroom, 1889
The Drinkers (after Daumier), 1890
Cleveland
The Cleveland Museum of Art
Large Plane Trees, November 1889

Indianapolis
Indianapolis Museum of Art
Enclosed Wheat Field with Peasant,
October 1889
New Haven
Yale University Gallery
The Night Café, September 1888
New York
John Hay Whitney Collection
Self-Portrait with Palette,
August 1889
The Metropolitan Museum of Art
Two Cut Sunflowers, late summer
1887
*L'Arlésienne: Madame Ginoux with
Books*, November 1888
Mother Roulin with Marcelle,
December 1888
Museum of Modern Art
Starry Night with Cypresses,
January 1889
Pittsburgh
Carnegie Museum of Art
Le Moulin de La Galette, Summer
1887
Wheatfield Under Thunderclouds,
July 1890

PRIVATE COLLECTIONS
Beach with People Walking,
September 1882
Portrait of Père Tanguy,
Summer 1887
*Falling Autumn Leaves
(Les Alyscamps)*, October–
November 1888
Self-Portrait with Bandaged Ear,
January 1889

Chronology

The following is a brief overview of the main events in the artist's life, plus the main historical and cultural events of the day *(in italics)*.

1853
30 March: Vincent van Gogh is born in Groot Zundert in the Netherlands, the son of the Protestant pastor Theodorus van Gogh and his wife Anna Cornelia, née Carbentus.

The Crimean War breaks out.

1857
Baudelaire publishes his poems Les Fleurs du mal *and is accused of offending public morals.*

1859
Charles Darwin publishes Origin of Species.

1861
In Great Britain, Prince Albert dies. The American Civil War begins.

1862
Slavery is abolished in the United States. Victor Hugo published his novel Les Misérables.

1863
Édouard Manet exhibits Déjeuner sur l'herbe, *which is regarded as marking the beginning of Impressionism.*

1864
Attends Jean Provily's school in Zevenbergen (–1866).

The first International Workers' Association is founded.

1865
President Abraham Lincoln is assassinated. End of the American Civil War.

1866
Attends the middle school in Tilburg.

Alfred Nobel invents dynamite.

1868
Leaves school and returns to Groot Zundert.

1869
Becomes an apprentice in the branch office of the art dealers Goupil in The Hague.

1870
Jules Verne publishes Twenty Thousand Leagues Under the Sea. *Outbreak of the Franco-Prussian War: Claude Monet and Camille Pissarro flee to England.*

1871
Popular uprising of the Paris Commune. Giuseppe Verdi's opera Aida *first performed*

1873
Start of the intensive correspondence between Vincent and Theo van Gogh. Vincent is transferred to Goupil's London branch.

Arthur Rimbaud publishes Une Saison en Enfer.

1874
First Impressionist exhibition.

1875
Works at Goupil's headquarters in Paris.

1876
Resigns from Goupil and travels to England. Preaches his first sermon, in England.

Stéphane Mallarmé publishes his poem L'après-midi d'un faune.

1877–1878
In Amsterdam, prepares for the entrance examination for his studies in Theology, but is not accepted.

1878
Henry James publishes Daisy Miller.
Universal Exposition in Paris.
Thomas Edison patents the cylinder phonograph.

1879
Louis Pasteur develops rabies vaccine in France.

1879–1880
Works as a lay preacher in the Borinage district in southern Belgium; starts to draw in earnest.

1880
Fyodor Dostoevsky publishes his novel The Brothers Karamasov.

1881
Stays at his parents' house in Etten.

France occupies Tunisia. Start of the reign of Tsar Alexander III.

1882
Britan occupies Egypt. Camille Pissarro paints Harvest.

1882–1883
Settles in The Hague and lives with a prostitute, Sien.

1883
Guy de Maupassant publishes his novel Une Vie (A Life).

1883–1885
Lives at the family home in Nuenen.

1884
Joris-Karl Huysmans publishes his novel À rebours (Against the Grain).

1885
Death of Van Gogh's father.

Émile Zola published his novel Germinal.

Paints *The Potato Eaters*; in November, moves to Antwerp.

1886
Haymarket Riot take place in Chicago. Last Impressionist exhibition.

1886–1888
Lives in Paris with his brother Theo. Paints cityscapes, landscapes, still lifes, self-portraits.
First contact with the Impressionists.

1888
Moves to Arles; in November he is visited by Paul Gauguin.
Paints a great deal, especially landscapes.
23 December: in a fit of madness he cuts off part of his left ear.

T.S. Eliot is born in St. Louis, Missouri.

1889
Becomes a voluntary patient in the mental hospital at Saint-Rémy.

The Eiffel Tower is erected in Paris.

1890
January: the first essay on his work published: *Les Isolés: Vincent van Gogh*, in *Mercure de France*.
18 January–23 February: his works are exhibited in Brussels at the Salon des Vingt, where *Red Vineyard* is sold (first and only painting by Van Gogh to be sold during his lifetime).

20 May: Moves to Auvers-sur-Oise, near Paris.
27 July: shoots himself in the chest; he dies two days later.

Literature

In Van Gogh's own words:

Arnold Pomerans, *The Letters of Vincent van Gogh*, London 1997

The Van Gogh Museum in Amsterdam provides Van Gogh's complete letters online: http://vangoghletters.org/vg/

Studies:

Wilhelm Uhde, *Van Gogh*, 1937. English translation: *Van Gogh*, London 1951

Meyer Schapiro, *Van Gogh*, New York 1969

Albert J. Lubin, *Stranger on the Earth: A Psychological Biography of Vincent van Gogh*, New York 1972

Griselda Pollock and Fred Orton, *Vincent van Gogh*, London 1978

A.M. and Renilde Hammacher, *Van Gogh: A Documentary Biography*, London 1982
A.M. Hammacher, *Vincent van Gogh: Genius and Disaster*, New York 1985

Melissa McQuillan, *Van Gogh*, London 1989

Philip Callow, *Vincent van Gogh: A Life*, Chicago 1990

Robert Hughes, *Nothing If Not Critical*, London 1990

Jan Hulsker, *Vincent and Theo van Gogh: A Dual Biography*, Ann Arbor 1990

David Sweetman, *Van Gogh: His Life and His Art*, New York 1990

Ingo F. Walther and Rainer Metzger, *Van Gogh: The Complete Paintings*, New York 1997

Kathleen Powers Erickson, *At Eternity's Gate: The Spiritual Vision of Vincent van Gogh*, Michigan 1998

Alfred Nemeczek, *Van Gogh in Arles*, Munich and London 1999

Judy Sund, *Van Gogh*, London 2002

Bruce Bernard (ed.), *Vincent by Himself*, London 2004

Sjraar van Heugten, *Van Gogh the Master Draughtsman*, London 2005

Martin Gayford, *The Yellow House: Van Gogh, Gauguin, and Nine Turbulent Weeks in Arles*, London 2006

Simon Schama, *Power of Art*, London 2006

Belinda Thomson, *Van Gogh Paintings: The Masterpieces*, London 2007

Photo credits